PUNCH FIRST

A 21-Day COMBAT Guide to Playing Spiritual Offense

BETH GUCKENBERGER

DAVID **C** COOK

transforming lives together

PUNCH FIRST
Published by David C Cook
4050 Lee Vance Drive
Colorado Springs, CO 80918 U.S.A.

Integrity Music Limited, a Division of David C Cook
Brighton, East Sussex BN1 2RE, England

The graphic circle C logo is a registered trademark of David C Cook.

The website addresses recommended throughout this book are offered as a
resource to you. These websites are not intended in any way to be or imply an
endorsement on the part of David C Cook, nor do we vouch for their content.

Details in some stories have been changed to protect the identities of the persons involved.

Bible credits are listed in the back of the book.

ISBN 978-0-8307-8260-4
eISBN 978-0-8307-8266-6

The Team: Michael Covington, Stephanie Bennett,
James Hershberger, Jack Campbell, Susan Murdock
Cover Design and Interior Illustrations: Nick Lee

Printed in the United States of America
First Edition 2022

1 2 3 4 5 6 7 8 9 10

101321

To Back2Back staff and all those who stand in the way of an enemy hell-bent on the destruction of vulnerable children.

"Behold, I am sending you out as sheep in the midst of wolves, so be wise as serpents and innocent as doves."

MATTHEW 10:16 (ESV)

CONTENTS

Do the Work

INTRO

Welcome, I'm glad you're here! What you are holding is my attempt to write what author Anne Lamott once described as something I "would be delighted to stumble upon." Part encouraging, part challenging, it is designed for you to do on your own or with a small group. Personally, I experienced radical spiritual growth when I dove into these topics with a few close friends. I found myself:

- Released from some habitual sinful thought patterns
- Equipped to become spiritually assertive
- Educated on the "fuzzy details" of spiritual warfare
- Empowered to fight like a warrior and not wait like a victim

The purpose of this book is to understand spiritual battle and equip you to confront the Enemy. To do this, I will outline the tactics of our enemy, but know that Day 13 is where we get into the fierce personal battle of COMBAT.

My hope is you will look forward to the next few weeks when we ask hard questions of ourselves, each other, and God, while simultaneously being encouraged and challenged to proactively fight against the Devil.

This journal was written to interact with the content in the *Throw the First Punch* book, so it will be a richer experience if you have already read it. It's full of personal stories and biblical teaching on this topic. However, within this journal we'll process through those same principles (just not as in-depth), and you will still engage effectively without that foundation. You'll find the journal broken into four sections:

Days 1–5: We'll recap the ideas covered in *Throw the First Punch*.

Days 6–12: We'll review the many tactics our enemy uses to try to destroy us.

Days 13–18: We'll unpack the acronym COMBAT and practice using it in battle.

Days 19–21: Finally, we'll set out to do the work of fighting in a spiritually aggressive stance.

COMBAT is the battle plan you're looking for that can be applied in every area of your life. The first time through this journal, you will learn the process. When subsequent battles arise (and there will always be another battle …), you can work through COMBAT on your own using the blank COMBAT plans provided (see the appendix). My prayer is that you will feel empowered to fight, rest, share, be vulnerable, and take risks. This is the rhythm of a kingdom warrior.

 Before we begin, let's pause for a personal assessment. This is a place for you to record your current understanding of and feelings about spiritual warfare and a spiritual enemy. We'll check back after you complete the 21 days to see how your understanding grew.

✸ What do you believe about the Devil?

✸ How often do you think he tries to interfere in your life?

✵ What is your role in his defeat?

✵ What does a victorious life look like?

Recap

The following days offer interactive questions and exercises based on the stories and ideas from this journal's companion book, *Throw the First Punch*.

DAY 1

How This Works
A Tale of Two Storylines

I was on a walk with my husband, Todd, and we were planning a getaway for just the two of us. Although the conversation started with the right intention, before long we were irritated with each other, disagreeing on where to go, how much to spend, how long to be away ... We walked for a while in silence until Todd had the wisdom to ask, **"What do you think the Enemy wants to happen here?"**

Although in that moment I still wanted to win the argument, and I didn't want to go anywhere with Todd, I knew he was asking the right question. Underneath all my big feelings and selfish thinking, the truth is I would rather work *with* Todd *against* an enemy who didn't want us to connect, or rest, or dream than work *against* Todd *for* the Enemy.

We can partner with God to see regrowth and rebuilding, or our sin nature can partner with the Enemy, and without wanting it, we can propel forward the goals of the Devil. Paul wrote, "Put on the full armor of God, so that you can take your stand against the devil's schemes. For our struggle is not against flesh and blood, but against the rulers, against the authorities, against the powers of this dark world and against the spiritual forces of evil in the heavenly realms" (Eph. 6:11–12).

In 1 Peter, we read about an enemy roaring around like a lion, wanting to devour us. I believe the lion is circling, and I want to take a stand. I am tired of the teaching that says to put on the armor and wait for the Devil to come to you. **What if we decided to go after *him* and punch him first?**

✺ Write out 1 John 3:8 here:

God has invited His people to partner with Him ever since Genesis. Sometimes that is building a kingdom of heaven here on earth, and sometimes it's collaborating with God to destroy the Devil's work. I don't have to sit around and be frustrated about the state of the world or the struggle I have with a particular sin. I am biblically encouraged to dismantle what the Devil is constructing around me. Since all work by God—restoration, reconciliation, redemption, rescue, and repair—is opposed by our spiritual enemy, I can imagine with stunning accuracy the Devil's agenda.

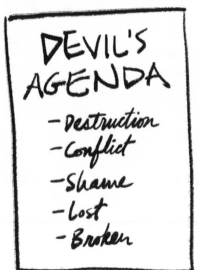

Instead of restoration, he wants destruction. Instead of reconciliation, he wants us to remain in conflict. Instead of redemption, he wants us to experience shame; instead of rescue, he wants us lost; and instead of repair, he wants us to feel permanently broken.

The Enemy will tell stories through our lives. When we don't put up a fight, and instead hand our sin nature over to him, he'll use it against us. There is much that factors into how we think, feel, and act—our past experiences, generational sin, spiritual discipline, temperament, accountability … We can learn to see beyond what is unfolding around us and train for the spiritual combat we are invited to engage in.

When I was finishing as an interim lead pastor in a church, it was time to introduce the staff to my permanent replacement. I started a chapel with this question, "If you were the Enemy, what would you do over the next month to derail this ministry?"

The team immediately responded:

> "Cast doubt over the new pastor's intentions."
> "Create misunderstanding in meetings or over email."
> "Divide us over something seemingly small."
> "Craft competition or jealousy."

I shared, "When you see any of these potential situations unfold, rightfully assign blame to the Enemy, who is biting on our insecurity or unconfessed sin (or someone else's). Let's confess any of our own wrong thinking and ask a blessing over whomever else is in the story."

This was more than a situation where humans decided if their personalities would mix well with others. It was a spiritual battle with the Enemy's goal of keeping God's people critical of one another and distracted. We brainstormed ways to play spiritual offense, including initiating with the new leader and praying for his adjustment. We imagined a culture with short accounts, where everyone gave the benefit of the doubt and sin had no soil to flourish. The result was a community of hopeful sojourners, not perfect, but in motion, proactive, and healthy.

Let's start this journey by thinking through the contrasting storylines we see at work in the world today. **In the following chart, list God's storyline along with its enemy counterpart.**

GOD'S STORYLINE	ENEMY'S STORYLINE
Peace	Chaos
Gentleness	
Hope	
Sacrifice	Selfishness
	Fear
Reconciliation	
	Destruction
Grace	Condemnation
Love	Hate

I now walk into every situation asking myself these questions, *What would the Enemy want to happen here? What's his agenda?* so when I see (for example) fear, harshness, selfishness, or chaos unfold, I know to fight against Satan and not the people in the story. Punching first is owning a distinct strategy where I invite peace into fearful conversations, or purposing to be graceful when I sense harshness, or disciplining myself toward generosity

when I'd rather be selfish. We don't react when attacked, but instead move the spiritual momentum in the direction of kingdom advancement.

Todd and I are walking alongside a couple who is struggling in their marriage. Our own punch-first strategy is to make sure we are investing in each other, knowing if we aren't strong, we will be less likely to believe we have something to offer them. We have a child graduating from high school this year without a clear plan, and our punch-first strategy is to remind him of what we do know, so while the Father of Lies whispers to him, he has something to hold on to.

When I see every story and conversation as spiritual, I feel commissioned to spiritually fight. It's different from waking up and acting a certain way because of how I feel. I don't have to wonder if he wants to attack my self-image, family, marriage, friendships, and ministry. I know the Devil wants me spun around and confused. He wants me silent and ashamed. I don't want to wait for his attack while on defense. I want to offensively take ground from him. He does the same things over and over again; we can read about his tricks in Scripture and testify to his tactics in our own lives. We don't need to tiptoe around the Devil or hide from him. Knowing he's coming, we can learn to spot him from a mile away. How do we protect ourselves and those we love?

� Everything is spiritual, so what's a situation you are facing right now, and what do you imagine the Enemy really wants? How could you make a spiritually offensive move?

�֍ Paraphrase Luke 10:19 below. What does it tell us about our spiritual power?

✖ What questions do you have about evil or enemy activity?

John 10:10 promises that God wants us to have a life "to the full." It's worth fighting for. The world God created is good, but it's not always safe. Some of the not-perfect and unsafe experiences are a result of living in a fallen world. We get sick, people die, and it's not fair. Some of the not-perfect and unsafe is because we sin or others sin, and the consequences are destruction, conflict, loss, and brokenness. Finally, some of the hard we experience is designed by our adversary, who is relentlessly on the attack.

Could we know this to be true and live a life where we advance spiritually, rather than just, at best, hold him back? What if we became so adept at offensive sword wielding that God would ask us to fight for others?

About a quarter of everything Jesus talked about in Scripture had to do with spiritual warfare. He knows how much it impacts our lives and is pleased when we willingly engage with Him in battle. The most powerful spiritual step I can take is to walk into every room and ask, *What would the Enemy want to happen here? What's his agenda?*

> *God, teach me to have eyes to see that what's happening around me is spiritual. I want to come to You with my questions and to be led by You. Show me the spiritual power You designed for me to wield in Your name. I am Your child and student. Amen.*

DAY 2

Everything Is Spiritual

What does the Enemy want? He wants me distracted with sin.

One of our campus programs provided homes for vulnerable children to live with house parents. At one of these homes, the grace-filled and gifted house parents were raising their own children while fostering six young men. They had arranged a predictable schedule including after-school snacks and connection time, homework help, dinner prep, and discussion during dinner. One of the boys had been there a month when I was called in to help regarding an episode he had instigated during dinner. When I arrived, the parents were dysregulated and frazzled, but the boy was calm and seemed happy.

"What happened?" I asked him. I was eager for his perspective, having already heard from the parents details involving food throwing, disrespect, and picking on another boy.

He took a deep breath, one that sounded like relief. "*Finally*, I can breathe. Everyone was being so nice around here, and I felt like I was drowning. Once I started the fighting, and everyone was upset, it felt normal again." It was true—he seemed almost peaceful. Having grown up in an environment where dysfunction was *his set point*, he was desperate to feel normal again.

The Enemy wants to distort our set point, or default, so isolation feels natural, and we work to self-sabotage relationships. When we find connection in healthy relationships, it would serve him well for those to break or for

us to at least doubt them. He will bite at us until we either confess our sin and overcome, or fall to our sin and suffer defeat, destroying connection and promoting isolation.

�֍ In what ways has your set point been distorted to find sin familiar and comfortable?

In Genesis 4, God spoke to Cain. Remember the two brothers Abel and Cain? Cain was the bad one, where we get the expression "raising Cain." He eventually murdered his brother. God warned him in verse 7, "You will be accepted if you do what is right. But if you refuse to do what is right, then watch out! Sin is crouching at the door, eager to control you. But you must subdue it and be its master" (NLT).

We have sin crouching at our doors. My sins are different from yours—a combination of childhood experiences, generational patterns, bad habits, personality weaknesses, and trauma. Satan knows exactly what's at my door, and he knocks repeatedly, hoping temptation will cause me to open it. When I do and it masters me in the moment, there is always grace and the Bible promises no condemnation (Rom. 8:1). However, earthly consequences ensue, and the bullet I hand the Enemy, he uses to shoot me.

What sins crouch at your door? In the following chart, list those sins (on the left), and write down your thinking of where those sins originate within you (on the right). Some examples of sins are: judgment, fear, envy, pride.

THE SIN	ITS ORIGIN
_____	_____
_____	_____
_____	_____
_____	_____
_____	_____
_____	_____

When my sin defeats me, the shame I feel can drive me into further isolation, which then becomes fertile ground for distorted thinking. It's why we believe, *If they really knew what I am/do/think …* or *If I can protect "this," then I am safe.* It allows lies to linger. The Bible illustrates the Enemy using this trick on David and Peter, two unique biblical characters who fell into sin and needed their communities for restoration. God isn't stuck in the day we experience isolation and feel out of fighting shape. He sees what's coming and cheers us on to get up and keep battling. Not sinning isn't an option; we are fallen. Allowing sin to create space between us and our people? Us and God? That's allowing the Enemy to win twice, and in this war, we can't afford it.

The Enemy is counting on us being scared of the dark or fearing another person's pain is contagious, but if we keep our eyes open, we'll become more comfortable wading into the dark and turning on the light. Practically speaking, this means a willingness to be in close proximity to someone's pain, or

not backing down from a challenge, or walking into a situation where chaos has ensued.

I get most tired spiritually, or discouraged, when I think it's up to me to save someone or something. I cannot fix what God wants to heal. I've made this rookie mistake more times than I want to count. I was certain if *I* didn't do something, all would be lost. I now know better: there is only one Savior who died on a cross. Anything I offer, I do so as His ambassador. He does the prompting, calling, empowering, rescuing, and saving. I just fill up and pour out—giving only what I have received from Him.

Among the Enemy's bag of tricks is to hide himself behind attacks of isolation, temptation, and shame. If we don't see him, don't believe he exists, or don't understand his tactics, he gets twice the mileage. He attacks and creates chaos, then we blame ourselves for it and, embarrassed, don't look or ask for help. When we acknowledge the reality of evil, we stop seeing the Devil as a caricature and understand his utter bent on our destruction.

� What lies from the Enemy's whispering have you believed?

✧ Write out John 8:44 below. What does it tell us about the nature and power of the Enemy's words?

✧ What is one situation in your life you've seen the Enemy provoke or exploit?

Lord, I confess the sins crouching at my door. Help me to keep it closed in Your name. I want my set point to be Your holiness. Help me see where I am giving power to the Enemy to advance his kingdom. I believe in You, and I believe You. Amen.

DAY 3

Listening Prayer

What does the Enemy want? He wants me to feel distant from God.

I was in a heavy season, exhausted from all the moving parts. I asked some friends to pray for me and they suggested praying *with* me instead. We sat down and I expected them to talk to God, asking Him for my strength or provision. But we sat in silence, and they listened and spoke back to the Lord what they heard.

Listening prayer is an important skill in spiritual warfare. It's how God can alert us to enemy activity of which we would otherwise be unaware. Only God can see the unseen, and being still before Him and listening to Him are like putting on night goggles. Suddenly what's in the dark is illuminated.

As my friends prayed over me, one of them shared a vision of a five-speed car stuck in fifth gear. That gear is ideal for going fast, but you can't park or change lanes in fifth gear; it limits your versatility to stay in the same gear all the time. As we prayed over that image, I realized I was valuing fast over all else and missing out on some of what God wanted me to do (tricky "driving" required more finesse than I was allowing).

I had been believing lies, I had unconfessed sin, and it came to light when I sat quietly before the Lord. "If any of you lacks wisdom, you should ask God, who gives generously to all without finding fault, and it will be given to you" (James 1:5).

�֍ When was the last time you asked God for wisdom? What was the result?

✖ How do you make time to listen to God? What is something you sense He's telling you now?

We can hear from God through Scripture and in our worship. We can hear from Him through other people and by sitting quietly in prayer. We may see an image, or have a dream, or experience Him in nature. We will recognize when He speaks to us if we're listening. Jesus says we are His sheep, and we can follow our Shepherd because we recognize His voice. "The gatekeeper opens the gate for [Jesus], and the sheep listen to his voice. He calls his own sheep by name and leads them out. When he has brought out all his own, he goes on ahead of them, and his sheep follow him because they know his voice" (John 10:3–4).

There are a lot of voices calling to us, but Jesus says His sheep won't follow voices they don't recognize. "They will never follow a stranger; in fact, they will run away from him because they do not recognize a stranger's voice" (v. 5).

✖ What voices influence you?

✖ How do you hear God's voice?

In 2 Kings, God revealed enemy movements to Elisha.

> Now the king of Aram was at war with Israel....
>
> The man of God sent word to the king of Israel: "Beware of passing that place, because the Arameans are going down there." So the king of Israel checked on the place indicated by the man of God. Time and again Elisha warned the king, so that he was on his guard in such places.
>
> This enraged the king of Aram. He summoned his officers and demanded of them, "Tell me! Which of us is on the side of the king of Israel?"
>
> "None of us, my lord the king," said one of his officers, "but Elisha, the prophet who is in Israel, tells the king of Israel the very words you speak in your bedroom."
>
> "Go, find out where he is," the king ordered, "so I can send men and capture him." The report came back: "He is in Dothan." Then he sent horses and chariots and a strong force there. They went by night and surrounded the city.
>
> When the servant of the man of God got up and went out early the next morning, an army with horses and chariots had surrounded the city. "Oh no, my lord! What shall we do?" the servant asked.
>
> "Don't be afraid," the prophet answered. "Those who are with us are more than those who are with them."
>
> And Elisha prayed, "Open his eyes, LORD, so that he may see." Then the LORD opened the servant's eyes, and he looked and saw the hills full of horses and chariots of fire all around Elisha. (2 Kings 6:8–17)

If I could see the hills around me, how would that change how I walk through life? Psalm 68:17 says, "The chariots of God are myriads, thousands upon thousands" (NASB). Do I believe they have been dispatched to provide and protect me as I engage in cosmic battle?

✬ Sometimes God speaks to us in big, undeniably demonstrative ways, but that isn't always the case. Read 1 Kings 19. What does it teach us He can sound like?

Listening Prayer

Engage in listening prayer by completing the sunbursts on the following pages.

Spend five minutes writing what you are thankful for on the blanks.

Use the next five minutes to write what you hear God saying to you.

Take the final five minutes to record your requests to God.

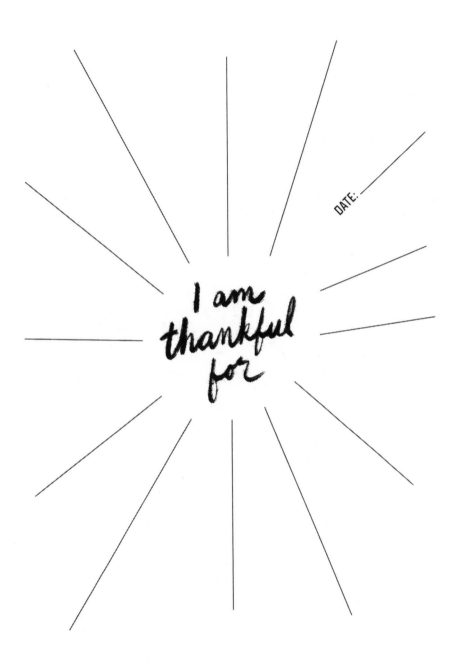

DATE: _____

I am
thankful
for

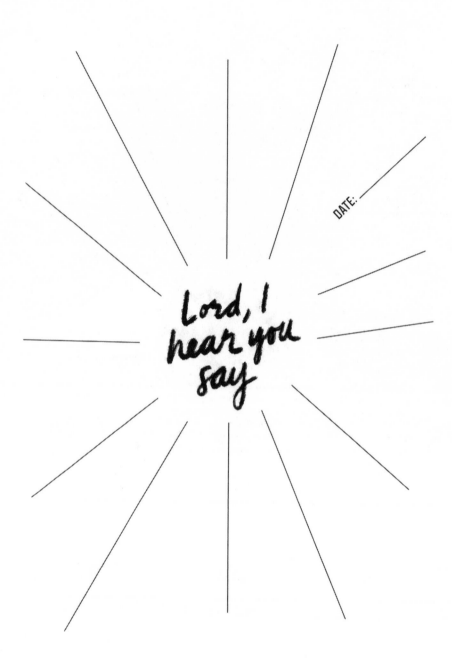

DATE: _____

Lord, I hear you say

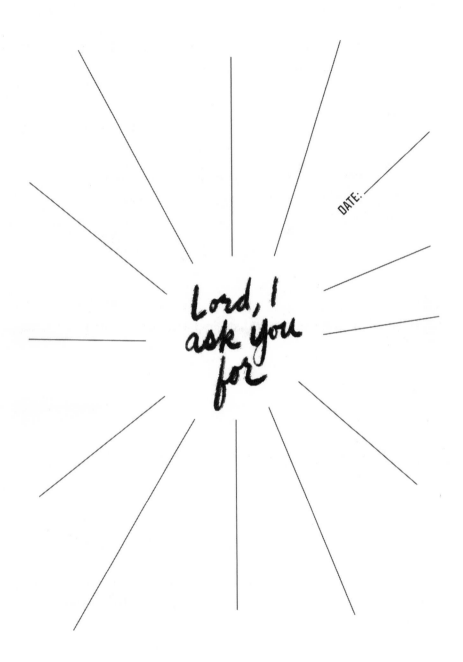

DATE:

Lord, I ask you for

Now sit with your sunbursts and listen …

1. Come to God and be specific: What are you asking Him? You can use this time to repeat Scripture, remembering His promise to listen.

2. Tell Him with the authority you have as a co-heir with Him, that you ask Him to bind any enemy activity around you (refer to *Throw the First Punch*, chapter 26).

3. Wait in silence. Use a journal, or sit quietly, but most importantly, be still.

4. Write down any verse, image, or song that comes to mind. Sit with it for a minute, then ask God for further insight.

5. Sometimes what I hear from God I feel compelled to share with others; sometimes it's just for me and Him. Ask Him what He wants you to do with what you've heard.

� How do you see listening prayer being an effective practice in spiritual warfare?

Lord, I want to hear from You. Teach me to listen for Your voice and to have the courage to obey. Amen.

DAY 4

The Joke's on Him

What does the Enemy want?
He wants me to say no.

Early in my missionary career, I agreed to provide translation during a sermon from Spanish to English for a visiting team. I didn't speak well enough to do it, but (in pride, bravado, availability?) I said yes. After five minutes, it was clear I was in over my head, and the voices of doubt crept in.

Who are you pretending to be? Everyone can see you are a fake. What else can you not do well? This is just another moment of failure.

The mental war of competing negative thoughts and frantic translation was too much; I couldn't do it all. I prayed for a moment and lost track of what the pastor was saying. When I said "amen" to myself, he was in Galatians, a book I had just finished studying. I took a bit of what I knew he was saying and a bit of what I had learned myself and mashed it together to finish the message. I loved it! So much so, I volunteered the next time and the next. I learned how to preach (reading an audience, using humor, telling stories) in part through poor translation. Most weekends now, I am filling a pulpit. The Enemy wanted me to fail, but God had other plans. It's just one example of hundreds in my life where the joke has been on Satan.

Romans 8:28 says, "And we know that in all things God works for the good of those who love him, who have been called according to his purpose." And Jeremiah 15:19 teaches, "If you extract the precious from the worthless, you will become My spokesman" (NASB). No matter how hard the Enemy tries, his work in our lives can not only be redeemed, but God can use it for His glory through our testimony.

There's a story in Mark 4 and 5 that begins with Jesus talking to His disciples in Capernaum, telling them He wants to cross the Sea of Galilee to visit the Decapolis. All we read in our Bibles is that the disciples obeyed, but imagine for a moment, with some context, how they might have wrestled with this assignment.

First of all, they would have to cross a large body of water, which in that time was metaphorical for the abyss—a belief fed by stories of Jonah and Noah. Maybe they didn't want to cross the abyss, and for whom? Some in the Decapolis (we now know thanks to archaeologists) were worshipping the gods of fertility and wine.

However, the disciples obeyed, and when they climbed into the boat, the abyss did to them exactly what it does to us every time we say yes to following God—it kicked itself up into their faces. In their case, it came as a storm.

�֍ What storms have you faced from saying yes to Jesus?

Jesus taught those disciples—and the rest of us—exactly what to do when the activities we are engaged in are spiritually opposed. Jesus silenced the storm with the words from His mouth, "Peace, be still!" (Mark 4:39 NKJV). I have access to this same power, as He's given me through the Bible words out of His mouth.

�What do you usually pray or say when you feel darkness closing in?

They arrived in the Decapolis, and Jesus was met on the shore by a demon-possessed man named Legion. He had blood in his body and breath in his lungs; however, his friends and family had chained him to a gravesite, his life already considered worthless. Emboldened by those demons, he broke free from the chains and came up to Jesus. Jesus took one look at him and knew exactly what was going on. Up on the Decapolis cliffside He saw pigs, which were often sacrificed on the altars of the gods of fertility and wine. He cast the demons into those pigs, and they ran off into the sea.

> As Jesus was getting into the boat, the man who had been demon-possessed begged to go with him. Jesus did not let him, but said, "Go home to your own people and tell them how much the Lord has done for you, and how he has had mercy on you." So the man went away and began to tell in the Decapolis how much Jesus had done for him. And all the people were amazed. (Mark 5:18–20)

Jesus got into the boat and crossed back over the abyss, going home to Capernaum. The first time my heart fully wrapped around this story, I thought, *He did all of that abyss crossing for one person? And it wasn't even the coolest person there? He crossed for the most unlikely, unwanted, discarded member of society.*

�Who crossed the abyss for you? Look at the following illustration and write on or underneath it how grateful you are for the person (or people)

who brought the gospel to you. Reach out to them, thanking them for the storms they faced following this call.

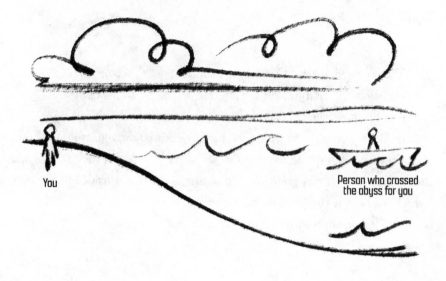

You

Person who crossed the abyss for you

We read more about this area, both in Scripture and in history, and learn Christianity exponentially grew in this place. When God decides to take back from the darkness what Satan has claimed as his, He's thinking about more than just the immediate moment or the person directly affected. God looks at whole lives, and when He frees us, it's not only for now, it's for stories and generations to come.

This is the heart of God: to deliver us from evil and to redeem what was stolen. The joke is on the Enemy; he is used unintentionally in our sanctification. As we fight the good fight and participate in what the Bible calls "good warfare," we draw closer to God and in our understanding of the realm we cannot see but cannot deny. It often starts with our *yes*. *Yes, I will step forward without all the information. Yes, I will speak up even if my heart is racing. Yes, I will take a thought captive. Yes, I will give when I would rather not. Yes, yes, yes.*

✧ What do Romans 2:4; 2 Corinthians 7:10; and 2 Timothy 2:25 have in common?

As one of my favorite Bible teachers, Sandra Richter, says, "What God started in the Garden of Eden (Genesis) and finishes in the New Jerusalem (Revelation) are bookends of a redemptive history. Everything in-between is one astonishing rescue plan."[1]

The spread of the gospel requires battle, and God set it up so we'd partner with Him in this fight.

✧ What has God rescued you from?

✧ Where do you sense God's invitation to fight for Him?

Lord, I am so grateful You came for me, and You use my choices—both good and bad—for my sanctification. Teach me to have eyes to see Your astonishing rescue plan and praise You for it. Amen.

DAY 5

He Uses the Same Tricks Over and Over

What does the Enemy want?
He wants me to feel stuck in shame.

Since the Bible says God came to destroy the Devil's work (1 John 3:8), we can infer the Devil is busy working on *something*. What exactly is he working on?

The Devil wants to *ruin* me and you. He knows hurting us will hurt God, and that's his goal. Satan is relentless in his accusations; he blames continually. He hates God and all that God is. He hates God's mercy and forgiveness extended to sinful humanity. But it doesn't matter what Satan says, because of Romans 8:33: "Who will bring any charge against those whom God has chosen? It is God who justifies." Satan desires to remind believers of their sin and unworthiness in order to sow doubt into our hearts and minds.

There are no original stories. Our enemy uses sex, money, and pride. He uses deceit, selfishness, and anxiety. We can read throughout both Testaments the stories of everyday people who didn't understand the deception they were under. The combination of their own weakness (within), the world (around), and the Devil (nearby) created havoc.

Even with all the verses, the subject of Satan and his spiritual warfare can be hard to put our theological fingers on. How can we, as Christians, become more fluent in this topic? We know he is real, but he isn't behind every door.

Sometimes when we fall to sin, we are simply tripping on our own weakness. At times, I have taken credit for mistakes the Enemy orchestrated and pretended what was happening was unfortunate instead of evil.

So many questions come to mind:

✺ How can we learn about him without giving him undue attention?

✺ How can we grow in discernment so we can notice his activity?

✺ If we learn his patterns, can we possibly predict him? And then, working within God's power, can we prevent his plans for our ruin, instead of just picking up the pieces afterward?

✺ How does Satan exploit my sin?

✺ Does he create circumstances where my weakness makes me vulnerable to sin? Does he push me? What does the Bible say?

✵ How can he be stopped?

Never again will I turn away from the invisible truth surrounding my life: I have an enemy who seeks to harm me but a Protector who can equip me for battle. (For more information on how this journey was activated in me, see the introduction in *Throw the First Punch*.)

When I fall to sin and lose my cool—say something I shouldn't, do what I know better not to do—there are *always* consequences. For our biblical enemy, those consequences are like stars on his report card. He loves the chaos that ensues because there's the danger of ruptured community and the fallout of shame. God wants to protect us from those consequences, because He knows they hurt. Although He's paid the price for our sin, we can struggle to remember we don't have to experience separation from Him.

✵ What consequences have you faced from sin?

✵ What does the Bible tell us about His forgiveness? Read 1 John 1:9; Psalm 103:10–14; Ephesians 1:7; and Matthew 26:28. Pick one of those scriptures and write it out below.

God never leaves us, and we read in Scripture that His eyes are always on us. However, we can try to hide from Him. In our shame, we may not call on Him, even though He is the very and only Person who can save us.

I had always thought the goal was to outrun or avoid the Devil with good choices. Just stay on the path, and he can't touch you. But looking back, I realize those messages came from people trying to convince me to live well. When I read my Bible, I can see that God has a more proactive approach; He wants me to face the Enemy rather than run as fast as I can in the other direction.

✸ What have you been taught about the Enemy?

The Enemy can't force me to be, for example, demanding or egotistical; I do that fine on my own. I have natural limitations, and if I don't ask for more of God to compensate for my weakness, then when I am triggered, sin results and the Devil wins. As I reach my limits, my nature itches to satisfy itself (give in), and I have choices. Will I confess my thinking? Will I run to God for spiritual rest? If I don't go to God for rest, selfishness inevitably manifests as impatience, intolerance, neediness, greediness, and pride.

All that *me*-focus hurts the relationships in my life. Whether things crash in a verbal conflict—leaving me feeling caught in my sin, now to apologize or defend—or in an internal conviction, I need God to be my Healer.

At this point I have to identify the difference between:

> *Guilt*: something I feel because I've done something bad and don't know what to do about it.
> *Shame*: something I feel because I (believe I) am bad.
> *Conviction*: prompting of the Holy Spirit to confess my sins.

Take a moment and list some of your most recent sins in the following chart. Walk through how it might sound to feel guilty, ashamed, or convicted about them.

SIN	GUILT (DONE SOMETHING BAD)	SHAME (BELIEVE I AM BAD)	CONVICTION (PROMPTING OF THE HOLY SPIRIT TO CONFESS MY SINS)
Lost my temper.	I feel bad. I yelled.	I am a hothead. I will never change.	It was wrong I yelled. I'm sorry...

Conviction brings freedom because I realize in His image and by His sacrifice, I am made right in His eyes.

✳ When is a time you've felt guilty or ashamed? How does it feel different from conviction?

What does the Bible say we should do with our conviction? Read 2 Corinthians 7:9–10; Acts 2:37; and Romans 8:1. Write one of those scriptures below.

Lord, teach me to come to You with my conviction. I trust Your work on the cross will cover me and free me from any shame. I am grateful for the freedom conviction brings. Amen.

Tactics Review

The following seven days will serve as an introduction to or a review of Satan's tactics and his intended outcomes with each one: when he'll try to trip us up, what the collateral damage will be if he wins, and what God says about them.

DAY 6

What does the Enemy want? He wants me afraid, isolated, and selfish.

In Back2Back's trauma training, we teach that everyone has a window of tolerance but the size of the window varies. How (with ease or annoyance) we manage the disruptions of our day, such as feeling inconvenienced or offended, depends on the size of our window. Fear plays a big role in our window size, and school pressure, society's expectations, political drama, financial challenges, and more can impact and shrink our window of tolerance. I see it when reading social media or attending a sporting event: we release steam in the smallest, most socially acceptable way possible but often at the expense of relationship. Fear builds Satan's playground.

"Is it a ten?" This is the question Todd and I have learned to ask each other when we perceive the other is overreacting. With a smaller window of tolerance and less emotional bandwidth, what might typically register a three on a scale of one to ten will suddenly have us dysregulated. On some days it can seem like *everything is a ten*, a sign I am afraid of something I can't admit and Satan is playing me. It requires enormous amounts of emotional energy to be afraid, energy better spent elsewhere.

✵ What has been a ten for you lately?

✵ Using the scale below, plot some major events from your life (when people entered in or out of it, accomplishments, stressors, etc.). Connect the event with a number on the scale, or simply list the events and assign a number next to each one.

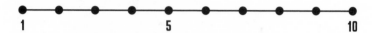

We take back ground when we recognize Satan as a liar and turn the "ten" moment into something holy. Here's an example. During the pandemic, I was accosted in a store because of how I was wearing my mask. Although I was naturally defensive out of fear (afraid I was being judged, afraid they were right, afraid of illness for them or me), I tried to imagine their tiny window of tolerance and respond with compassion and a silent prayer, acknowledging my own sensitivity and praying for theirs. What the Enemy wanted to become about fear and anger, I instead was able to turn into a moment of prayer for another person.

Take a fresh look at your scale. Do your tens seem justified? Do you want to de-escalate them? How can you ensure only the most important events are requiring the highest levels of your emotional energy?

How can I ensure I'm not triggered to respond with anger but instead am more peaceful? Soul care. It's my greatest tool to access the dwindling supply of peace and common grace with which I want to manage life. Soul care is a combination of self-care and establishing healthy spiritual rhythms. It's different for every person and circumstance you find yourself in. Sometimes I take a few minutes to collect my thoughts before I get out of the car and rush into the next place I'm heading. I am an auditory person, so listening to music or an audiobook helps me feel calm. I might also need to hydrate, nap, or exercise.

My family needs me at my best, and unfortunately fear is sticky and contagious. If I am intolerant with one of my kids or my husband, I am pouring my negativity into a household that thrives when we are all

loving and emotionally predictable. The consequences of me falling prey to fear don't stay isolated to me; they infect those around me. They will now have something to fear or be irritated by my distress. Either way, it's disconnecting—Satan's favorite outcome.

✵ How can you tell when your windows of tolerance are shrinking?

✵ What new ways could you practice soul care?

Spiritually, self-care is intentionally staying connected with God. John and Charles Wesley's mother, Susanna, had nineteen children. They told stories of when she would throw her apron over her head and say, "Give me a minute. Mama needs to go to the tent of meeting."[2] I resonate with her need for time alone with Jesus. I regularly tell Him I am running out of patience, self-control, peace, kindness, or perspective, and I ask for a supernatural supply.

✵ Where do you go to meet with God?

In Exodus 33, Moses went into the tent of meeting, a place where the Spirit gave direction and download to His people. Today, with the Spirit living in us, it's critical we ask Him for whatever we need, to stay self-aware enough to realize when our windows of tolerance are shrinking and when our next thoughts or words might not be beneficial. When I overcome a moment of fear and stand my spiritual ground, it's a win.

✵ Look up 2 Thessalonians 3:3 and write it out here.

A study done at the University of Cincinnati shows that 85 percent of what we fear never actually happens.[3] The Devil is shooting us with the equivalent of a water pistol, an old-as-the-book tactic that is overcome by God's peace, presence, and power, which achieve the dual accomplishment of empowering us to march forward on offense and stopping us from shrinking back protectively.

How can I punch first at my self-protective and selfish nature that often leads to isolation? In addition to walking in the Spirit, I can develop healthy relationships that create better self-awareness. The mind *flourishes* when in relationships of intentionally attuned connection. The good words and experiences deposited in my life inform my sense of self. Although best deposited in us as children, good words and experiences, and listening and play, can improve any relationship.

Of the three New Testament words for *love* in Greek, *agape* is in part defined as "compelled to act." It is the opposite of selfish.

✵ Have you ever felt compelled to act lovingly toward someone? What happened?

If I act in love, my "feelings" can change toward someone. "Love your neighbor" is not just thinking nice things about them; it's about getting up and moving toward them. If I am struggling to love someone, or am in conflict, the world says to make peace: I can meet them in the middle, find common ground, compromise, let things just "be," or walk away.

But Jesus didn't meet me halfway; He came all the way. Nothing announces who my spiritual Father is more than doing what's best for

someone else. That's how His family acts! Satan doesn't want God's family and His kingdom to be put on display, so he tempts me toward self-obsession. If I am preoccupied with my own needs and agenda, then I will make *my* world as good as it can be, even at the expense of others.

Nothing could be further from God's intent; He made the world of others better at His own expense. His way equals peace; the Enemy's way breeds chaos. James 3:14–16 teaches us, "But if you harbor bitter envy and selfish ambition in your hearts, do not boast about it or deny the truth. Such 'wisdom' does not come down from heaven but is earthly, unspiritual, demonic. For where you have envy and selfish ambition, there you find disorder and every evil practice." When we see these things of disorder, we know the Enemy is at work to cause confusion and division.

✻ Think of a time when you witnessed disorder. Record what it specifically looked like. Can you trace it back to someone's envy or selfishness?

We can do more than just play defense. We can play offense against an enemy desperate to disconnect and isolate us, and the quickest route to connection is active listening to one another and to the Lord. Paul said, "[Christ] gave himself for our sins to deliver us from the present evil age" (Gal. 1:4 ESV).

Selfishness and envy can be made to sound good when coming out of the mouth of someone who is smiling, but they are demonic. In contrast, God wants to bring His peace into disorder. How did He model that? With the total sacrifice of His Son.

Lord, help me to bring my fear, isolation, and selfishness to You. Teach me to think of others before myself. Amen.

DAY 7

What does the Enemy want?
He wants me discouraged, proud, and lost.

I use the Hebrew word *geshem* as if it's English. "Rain" might seem like a funny word to learn, but after understanding its context in Deuteronomy, I now ask God regularly for spiritual *geshem*.

> The land you are crossing the Jordan to take possession of is a land of mountains and valleys that drinks rain [*geshem*] from heaven. It is a land the LORD your God cares for; the eyes of the LORD your God are continually on it from the beginning of the year to its end. (Deut. 11:11–12)

In all of the Middle East, water is precious. In ancient times, countries that had water in abundance became superpowers (like oil today), and the countries with little water barely survived. The water available in Egypt from the Nile was thirty thousand times more plentiful than the yearly rainfall to Israel. Imagine how confusing it must have been to God's people during the Exodus when He told them there was a Promised Land, and yet it was far from water.

The difference between Egypt and Canaan was that in Egypt, the crops were irrigated by the labor of hand watering, while in Canaan the land was entirely watered by *geshem*, or rain. In one country, you might *think* you had

more resources, but you had to be self-reliant, or in the case of God's people, enslaved. When God chose a land for His people, He chose a place where they could have security not because of their own efforts, but rather because of their dependence on Him.

�帯 Where have you seen God provide *geshem* for you? Take a few moments to list twenty-five things God has provided for you.

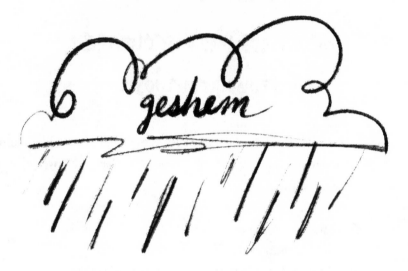

1. _____
2. _____
3. _____
4. _____
5. _____
6. _____
7. _____
8. _____
9. _____
10. _____
11. _____
12. _____
13. _____

14. _____
15. _____
16. _____
17. _____
18. _____
19. _____
20. _____
21. _____
22. _____
23. _____
24. _____
25. _____

When I feel discouraged, one way I fight back is by acknowledging what I've already seen God provide. The Enemy has no place to land his lies when we are focused on God's record of trust. Proverbs 26:2 says, "Like a fluttering sparrow or a darting swallow, an undeserved curse does not come to rest." When I see something designed to discourage coming at me, I remind myself, *This bird cannot land on me!*

� When do you most often lack trust in His provision for you?

When I was in a challenging parenting season with one of my children, I could feel discouragement setting in, and once it got a foothold, the littlest incident could be disheartening. My son and I were in the middle of a heated exchange and I knew I needed a time-out. I called a friend of mine, an expert in the development of children with traumatic histories. I wanted her to give me a quick answer, but instead she said, "Beth, breathe. Remember how far you've come, how far he's come. Worship." It wasn't what I wanted to hear in the moment, but she was right. I didn't need a list or a technique. I needed to let the discouragement roll off me, so I could reengage. What the Enemy wants is for us to quit, because a disengaged soldier is no threat.

✦ Whom do you call when you need help or encouragement? Why?

Most of the time, when I trace my sin back to its root, I find pride there. I get convinced my way is best and right, and I take credit for what I didn't do or haven't become. I need punch-first plans around pride, because without a strategy, it's too easy to allow this gateway sin to walk me into traps of judgment, greed, gluttony, and a whole host of other downfalls.

In his book *Mere Christianity*, C. S. Lewis wrote:

> According to Christian teachers, the essential vice, the utmost evil, is Pride. Unchastity, anger, greed, drunkenness, and all that, are mere flea bites in comparison: it was through Pride that the devil became the devil: Pride leads to every other vice: it is the complete anti-God state of mind....
>
> It is Pride which has been the chief cause of misery in every nation and every family since the world began.[4]

❊ Where has pride tripped you up? What vices has it led to in your life?

Consider the story of King Uzziah, who knew God and became king of Judah at age sixteen. He set his heart to seek God and put himself under the spiritual mentorship of Zechariah. As a result, "as long as he sought the LORD, God made him prosper" (2 Chron. 26:5 ESV). He became politically powerful and wealthy, which gave him a false sense of self and security, and he began to think more highly of himself than he should have.

❊ Read 2 Chronicles 26:15–21. What happened when he grew proud?

Again, these are old stories. We can also read about Eve, Haman, Nebuchadnezzar, or the Pharisees. And whether we are talking about biblical history or modern history, the pattern is predictable: if I gain something of value and take credit for it myself, I might as well spiritually beckon the Enemy to "Pick me!" God unsurprisingly will do whatever it takes, and take

whatever He needs to, so I am not vulnerable to pride and susceptible to enemy attack.

We once had a foster daughter run away from our home, and I remember being panicked. It was an out-of-control and completely disorienting feeling. I was in our bedroom praying and asking God for everything: wisdom, comfort, peace … and He brought me to this passage:

> For **I will** take you from the nations, and gather you from all the lands; and **I will** bring you back into your own land. Then **I will** sprinkle clean water on you, and you will be clean; **I will** cleanse you from all your filthiness and from all your idols. Moreover, **I will** give you a new heart and put a new spirit within you; and **I will** remove the heart of stone from your flesh and give you a heart of flesh. And **I will** put My Spirit within you and bring it about that you walk in My statutes, and are careful and follow My ordinances. (Ezek. 36:24–27 NASB)

God takes responsibility for the cleansing, the renewing, the gathering, the giving of a new heart. It's our job to join Him, to look for what is lost, and to rejoice when it is found. Whether people are physically lost—wandering away from community—or their minds have gone astray. "But I am afraid that just as Eve was deceived by the serpent's cunning, your minds may somehow be led astray" (2 Cor. 11:3). The Enemy wants our disorientation and blindness to prevent our grasp of the gospel.

�ער Write out 2 Corinthians 4:3–4 below.

There is nowhere the Enemy can lure us that God won't find us. It's a pointless tactic, but what the Enemy can achieve is sleepless nights, wasted

time, unnecessary panic, and scars from the detour. God has spent the resources to get us. He loves the lost and celebrates bringing us home.

Lord, teach me to give You credit for all the stories I find myself in and all the blessings You pour out on me. Amen.

DAY 8

What does the Enemy want?
He wants me to dim my light, too
weary to fight, and judgmental.

As a senior in high school, I was a cheerleader for the football team. On homecoming weekend, I was part of the court, and I was as surprised as anyone when they called my name and placed a crown behind my big, early-nineties bangs I had carefully hair-sprayed into place. After taking pictures on the sidelines at halftime, I rushed to the bathroom to change back into my uniform and was running late. I quickly checked the mirror before heading back down to the field to cheer, but in that hasty look, I didn't see the crown still buried underneath my permed hair. As I flew out the door, I ran into Lori, a frenemy who took the opportunity to say, "Oh, take that crown off your head; no one wants to see it on you." Flabbergasted, I reached up, yanked it off my head, and shoved it into my backpack, embarrassed and suddenly full of shame.

�֍ Can you think of a story from your childhood when you felt like you were too much or not enough? Below, or next to the following illustration, record a time when you sensed someone wanting you to dim your light.

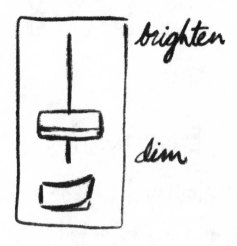

✺ Take a moment to reflect: In what situations or around which people do you brighten or dim yourself? Why?

Fast-forward fifteen years, and I was in Mexico talking to one of Todd's mentors about an opportunity I was being given to write a book. "I don't know if I will do it. It seems like a lot of work," I said, confusion in my voice.

"I don't know why you wouldn't. Seems like a great move for the ministry, and something you would enjoy. Why are you hesitating?"

I offered some lame excuses, and we volleyed back and forth, but each time he pressed a little more. I was getting agitated, clearly having some emotion stirred.

"I've heard you tell some good stories about your life in Mexico. How is this different, just this time you'd be writing them down?" he asked.

"Well, why me? Everyone here"—I gestured around, referencing other staff working within our vicinity—"has good stories too. What makes me the right one to tell them?"

"They asked *you*, that's why," he stated, matter of factly.

"No one wants to see that crown up on my head," I blurted, shocked as it was coming out of my mouth. "Oh *wow* …" I closed my eyes. Silence hung for a moment as realization dawned on me. "I can't believe it. I assigned her words to my voice. I almost said no to *this* because of *that*."

☼ Whose voice do you sometimes hear in your head? What's really behind it?

The Enemy had used the shame those words created in me to fashion a spiritual bruise. In that spot, he quietly built a nest, waiting for the right moments to use it against me. He won that night in high school and again every time since that I've shrunk back or dimmed like a switch the light God put inside me. When I look back and think about all the ways God used the book I released the next year, *Reckless Faith*, in my life and our ministry, it takes my breath away. I almost missed it because of a crown, someone else's insecurity, and a healthy dose of unresolved shame.

I recently sat at my son Aidan's basketball game, watching the time-outs, quarter breaks, halftime, and subbing in and out of players. I realized that if the players didn't come out of play to rest, their performance would get sloppier over time. The coach saw intermittent rest as a way to strengthen and sustain them in the game. Could it be the same with us and God?

☼ What role do you see rest playing in your spiritual battles?

After my double mastectomy, at times I struggled with pain during my recovery. One of my lasting lessons from that season was how *pain could make me mean*. When I didn't feel well, it was clear by the tone of my voice

and the sharpness of my demands. Eventually, the pain decreased and so did my touchiness, but the lesson remained.

Months later, I was at a sporting event and a grandmother was sitting with her preschool grandson, verbally lashing out at him. Prior to my surgeries, I might have been judgmental (*You don't talk to children that way …*), but now, watching her, I wondered where she might be hurting.

✺ When was the last time you were in pain? How did you respond to it?

Compassion and empathy moved me from *What's wrong with her?* to *What happened to her?* It is the counter swing of judgment. Today when I am tempted to judge, I ask myself, *How can I enter into this person's chaos and bring peace?* This works whether in person or watching the news or scrolling through social media. It puts me in a fighting posture for spreading the gospel and not being stuck in a place where the Enemy can use my weakness to further his agenda of spreading division.

✺ Who do you tend to judge? In what ways might they be hurting?

Satan wants us to believe we are unacceptable, unloved, and our security and identity are threatened. If he can lead me to thinking *There is something wrong with me* or *I don't have what it takes*, it's so painful I would rather ignore my own plank and look at others, pointing out their sawdust. The act of judging others has its origins in our self-judgment. Humiliated people humiliate other people. Once I realized this insight, when I heard myself or someone else engage in judgmental talk, I saw it as a window into the heart and an opportunity for ministry.

�֍ Who is someone you feel judged by? How can that person's comments to you provide insight into his or her pain?

The trick for me is to always remember I am *God's* kid. I am supposed to look like Him. And even He says in Romans 8:1, "Therefore, there is now no condemnation for those who are in Christ Jesus." Life can be relentless, and if at any moment I forget who I am in Christ, the result is walking around with an *orphan spirit.* That's the sense that I am not enough or that I don't have God's acceptance, love, and security. Jesus promised us He would "not leave [us] as orphans" (John 14:18).

> *Lord, I want to see others as You do. Teach me to pull back and rest when my nature to sin struggles. I want life to the full with You. Amen.*

DAY 9

What does the Enemy want?
He wants me oblivious, numb, and anxious.

The Evil One wants us blind to his work in and around our lives. He wins twice when we blame his shenanigans on other people and allow his interference to cause division. He seeps into the world so insidiously, we become comfortable with a low level of evil. We consume his kingdom in media, literature, and the arts without realizing it. Through this steady diet, we work up an appetite for his way. By the time we ask, "How did this happen?" we are already knee deep in his mud. I have walked into traps I knew better to avoid, I have ignored warning signs because it felt like the path of least resistance, and I have sensed evil work to get a foothold in me until confession was my only way out.

✨ Where do you see the Evil One working "undercover"?

Jesus walked His disciples many miles to teach them a lesson at Caesarea Philippi, the center for worship of the Greek god Pan. When they arrived, extraordinarily sinful behavior was on display. To the pagan, the mouth of the cave at the base of Mount Hermon was the gate to the underworld, where the fertility gods lived during the winter and then emerged each spring. In order to entice the return of Pan, pagans would engage in sexual activity with humans and animals. For the disciples, who had been following the Lord,

to see such overtly sinful behavior must have been a shock. Nothing subtle about literally knocking on the gates of hell.

Jesus doesn't want us to flinch at the sight of such evil or run from it. He walked them a long way for what happened next, and He asked them in Matthew 16:13, "Who do people say the Son of Man is?"

> They replied, "Some say John the Baptist; others say Elijah; and still others, Jeremiah or one of the prophets."
>
> "But what about you?" he asked. "Who do you say I am?"
>
> Simon Peter answered, "You are the Messiah, the Son of the living God."
>
> Jesus replied, "Blessed are you, Simon son of Jonah, for this was not revealed to you by flesh and blood, but by my Father in heaven. And I tell you that you are Peter, and on this rock I will build my church, and the gates of Hades will not overcome it. I will give you the keys of the kingdom of heaven; whatever you bind on earth will be bound in heaven, and whatever you loose on earth will be loosed in heaven." (vv. 14–19)

�షWhat kind of power do you think Jesus is offering when He says, "I will give you the keys of the kingdom of heaven"?

There's some debate on what these words mean, but we can't argue that "the gates of Hades will not overcome" implies Jesus and the disciples were being attacked. As a Christian, I might be asked to walk where I see enemy beachheads and trust what Jesus promised His disciples is true for me too. It was a big rock they were standing on when Jesus said those words, and since *Peter* means "rock," it might be easy to assume Jesus was saying He would build the Church on Peter. *I* wonder, however, if He was saying there is no

place, not even a rock where pagan sexuality is flaunted, that He can't redeem and build His kingdom upon.

I can't hide from evil or isolate myself from it. It demands confrontation.

�֎Write out key words you find in Matthew 16:24–26.

It's easier to walk a wide berth around the Caesarea Philippis of today or to watch the places like it just for entertainment. Worst of all, we may join in because it seems easier than fighting the culture. I confess that sometimes I tolerate sin because it feels unloving to call it out. I am asking God to show me the hurting people participating in culturally accepted sinful acts and paying for it with costly consequences. I am asking God for conviction when it's easier to stay unaware.

✗֎What comes to mind when you think of culturally accepted sinful acts?

Basta is a Spanish word meaning a combination of "stop" and "enough." When I first learned it, I used it to halt sibling fights and to stop a waiter from bringing a refill. But today, it is the command I use against our biblical enemy who is hell-bent on poisoning our lives. When I ignore the reality of the war I am in, I give him an advantage to sneak up on me, to taunt me with anxious thoughts I assumed I authored on my own, or to cast darkness over me. *Basta! I am ready to fight.*

What are my tools for this battle? Worship, prayer, and the Word of God. Employing these tools makes me stronger because they remind me of who God is. The Enemy can't read my thoughts; only God knows my heart (1 Kings 8:39; Matt. 9:4; Ps. 94:11). But Satan is watching my actions, and

they point to either my spiritual security or my flesh-driven anxiety. From there, it's just a matter of him pushing my buttons.

When the Enemy comes for me, my reaction matters. It can not only thwart his scheme but also draw me closer to God while simultaneously advancing the kingdom. If I want to exchange the lies in my mind with truth (the only real antidote to anxiety), I need to voice the thoughts in my head and assign them where they belong. When I practice a lie or doubt about myself for a long time (*I am not enough. I went too far. I am not good at* _____), I have to do more than disbelieve the lie; I have to practice the truth.

✨Review the chart below. Fill in the blanks, and list some lies you are tempted to believe and their corresponding truths. Can you find a verse that supports each truth?

LIE	TRUTH	VERSE
I can't figure it out.	I will direct your steps.	Proverbs 3:5-6
It's impossible.		Luke 18:27
	I love you.	John 3:16
I can't forgive myself.	I forgive you.	Romans 8:1
It's not worth it.	It will be worth it.	Romans 8:28
		1 Corinthians 1:30
I am not able.	I am able.	
	My grace is sufficient.	2 Corinthians 12:9
I can't do it.		Philippians 4:13
I'm afraid.		2 Timothy 1:7
I am alone.	I will never leave you.	Hebrews 13:5

We can feel anxious about absolutely anything—our health, the weather, money, our children, the future, the past, the present—and we can be tricked into thinking the best treatment plan is distraction, or the power of positive thinking, or contingency plans. But we don't have to live under anxiety anymore; God has delivered us from this sin. Because He is in control and good, no matter what comes our way, God is with us. Peace comes with acknowledgment of His sovereignty. This truth digested brings peace—regardless of circumstances.

Through praise and prayer (2 Chron. 20:15–17, 21–22; Acts 16:25–26; Phil. 4:4–9), rejoicing always and praying continually (1 Thess. 5:16–17), we can find peace.

> *Lord, help me to have peace in all circumstances: to be aware of Your truths and to live by them! Amen.*

DAY 10

What does the Enemy want?
He wants me to build my own kingdom, distracted with pleasure, and shamed.

We all have different pleasure triggers, and God warns us against them. The love of money is one example. If Satan can convince me stuff is preferable to purpose, then I busy myself with consumption. Worshipping what I own is a serious sin trap. When I get interested in my own comfort and safety over God's call, rather than stepping forward and raising my hand to be chosen, I lower it and try to fade into the background. Then I create a life that makes me feel good: whatever I want, however I want, as much as I want. I can get out of fighting shape pretty fast and, honestly, forget what the fight is all about. I can make idols out of money, my body, or my family and refuse to risk losing what makes me *comfortable*. When I choose to meet my own needs at the expense of obedience, consequences ensue. But when I battle well, I testify to God's blessing.

�శ What temptations of the world make you feel comfortable (materialism, gluttony, lust, pride, etc.)?

I can want something so badly that when I get it, whatever "it" is, I can love the gift over the Giver. That was what God was checking on with Abraham in Genesis 22, when He asked him to consider sacrificing his greatest gift: his son. While God didn't end up requiring Abraham's son, He wanted Abraham to experience the exercise of evaluation and sacrifice.

�֍ Read Genesis 22:1–18. What did God honor Abraham for?

I have poor friends who are crazy generous and rich friends who never seem to have enough. I have skinny friends who count their calories and other friends who never think twice about what they eat. There are parents who over-parent and end up driving their kids away and parents who work hard, ignore their children, and have the same result. So what is the formula for living a comfortable, happy, satisfied life? How can we have the body, bank account, family, and lifestyle we want?

And why do we want it exactly? Does it represent something to others or ourselves? These questions need to be addressed before I make decisions, not evaluated as I look back over the carnage of poor choices.

✖ What are you honestly striving for?

As a fifteen-year-old freshman, I had a lot to learn. (Disclaimer: this was not one of my prouder moments.) My youth group planned to travel by vans from Ohio, where I lived, to a ski retreat in New York. I was a few minutes late to the parking lot where we were loading up, so the only seat left was in the senior boys' van. I forced another freshman girl to join me in the back seat, where for the next several hours we sat in silence, listening to the guys

talk about past ski trips. They essentially ignored us, which was fine at first, but as the day wore on, I hoped at some point they'd acknowledge us.

Finally, one of the boys turned and asked, "So have you ever been skiing before?"

I knew if we said no they'd turn back around and we'd continue to be invisible. Unfortunately, I lied, rearranging the vocabulary I had heard them use in sentences over the prior couple of hours, giving the impression I was an accomplished skier. The result? One of the boys asked if I wanted to go down the first run with him. *Yes.*

✳ Have you ever pretended to know more about something than was true?

I didn't know how skis were sized, so after waiting in line with him, I asked for his same size, which should have been my first clue this would not end well. We climbed onto the chair lift, and during the long ride up, we talked about school, God, creation, and skiing. "This is an amazing black diamond run; you are going to love it," he said to me, casually putting his arm around my shoulders. Although I had no idea what a black diamond was, he was right about me loving it.

At the top, he joined others from our group. I waved him on, saying something about wanting to appreciate the view for a moment. The truth: I was scared out of my mind, and I could only pray, *Help.*

✳ What does Psalm 121:1 say?

I can go a lot of places when I need help; other people and other comforts tempt me. I can be lured into thinking something other than God will "get

me through" whatever battle I am facing. An enormously important practice in Christian discipleship is confession.

�֎Am I confessing when I need help? Is God my first call or my last resort?

As a first-time skier, I had only seen skiing on TV. Their technique was to put the poles under their armpits. After crouching down and pushing off, within minutes I passed the guys who had left long before I had. I was picking up speed and people were shouting ski terms, but since I didn't know anything about skiing, they didn't help. I could hear a snowmobile in the background and imagined they were coming for me. *How was this going to end?* The ski lodge was positioned to face the best run, so soon, the lodge came into view.

✤For David, he realized, "My _____ comes from the LORD, the Maker of heaven and earth" (Ps. 121:2).

This psalm is called a "song of ascent." David understood God was as present in the journey as He was in the destination. My prayer in the middle of any battle can't only be "When will this be over?" but "What do You have for me in the process?"

I strategized and prayed on that mountain. I could sit down, but it would mean broken ankles. I could run into the lodge, but that sounded painful. I spotted a ski rack to the left, so I leaned in its direction, hoping to break my fall and not my neck. *Oh God, I am sorry! Help me!*

By verse 3, Psalm 121 changes to make us a promise:

> **He will not let your foot be moved;**
> he who keeps you will not slumber.
> Behold, he who keeps Israel
> will neither slumber nor sleep. (vv. 3–4 ESV)

✵ Where do you need God's help to keep your foot solid?

God's Word promises that He is never caught off guard. The principles found in Ephesians, "take your stand against the devil's schemes" (6:11) and "stand your ground" (v. 13), instruct us to find a place to *stand*. The standing of the believer in Jesus is impressive. Take a moment to look up the verses below, filling in what we have to stand on.

_____	Romans 5:2
_____	1 Corinthians 15:1
_____	1 Corinthians 16:13
_____	2 Corinthians 1:24
_____	Galatians 5:1
_____	Philippians 1:27
_____	Philippians 4:1

I HAVE PLENTY TO STAND ON; HE WILL NOT LET MY FOOT BE MOVED!

People spilled out of the lodge when I crashed into (and scratched) the skis. The rest of the day was a blur of the infirmary, a forced ski lesson, and an invitation to dinner by the senior boy. I do still remember the liquid fear coursing through my body as I raced downhill. I was foolish and put myself in a terrible situation by lying.

When my foot slips, it's usually because I forget what's true. I give over some decision to the Lord, then I worry about it. Or I forgive someone but sense bitterness creeping in. Or I forgo an appetite of the flesh, then covet it in someone else's life. This makes my foot slip, but He still *keeps* me.

"The LORD is your keeper" (Ps. 121:5 ESV).

In the midst of seeking unholy pleasure, in the midst of kingdom construction for my own glory, thank You, Lord, for Your redirection and that Your "keeping" of me isn't dependent on my actions.

> *Lord, help me to see You as my Keeper—to trust You are always there for me. I want Your ways, I want what You provide, above all else … Amen.*

DAY 11

What does the Enemy want?
He wants me ignorant of the Holy
Spirit's power and self-absorbed.

A couple of years in a row, I spoke on the K-LOVE cruise, representing ministry to orphaned and vulnerable children, and holding information sessions on how to get involved. One year we saw little interest, and on the day we led an excursion to a local orphanage, only a dozen attended. I remember coming home and telling Todd I wondered if it was worth the commitment it required.

Six months later, I was talking to a friend who had adopted children from China and was an advocate for medically fragile or difficult-to-place Chinese children. She knew of a pair of elementary-aged sisters with complicated medical conditions who were proving difficult to place and asked if I would make an announcement on my social media. I wrote something about God placing the lonely in families (Ps. 68:6) and posted their picture and who to contact if interested. Plenty of people put heart emojis and wrote prayers in the comments, but as far as I knew, the only results of the post were education and exposure.

A year later, I received a long letter from a family who had attended one of the seminars on the cruise ship and subsequently followed me on social media. They had seen the post about the sisters and responded. The letter concluded with a picture of their entire family in California, complete with new Chinese daughters enjoying their first ice cream cones. I couldn't stop

thinking about all the places the Spirit moved to bring that family together. He fostered the relationships that cultivated the invitation to K-LOVE. He prompted the couple to attend my seminar and my friend to boldly advocate for the post. He knit together the hearts of the couple to be in agreement for such a brave assignment. He provided the resources, the open doors, and the courage for their adoption, and now He works in them to strengthen what He started.

✷ Looking back, what story in your life seems miraculous?

The Holy Spirit is a helper who teaches and reminds, convicts us of sin, fills and dwells in us, and is a source of revelation, wisdom, and power. He guides all truth, including knowledge of what is to come. He gives us spiritual gifts, helps us in our weakness, and intercedes for us. He makes all things new and sanctifies and enables believers to bear good fruit in their lives. He gets all the credit and is always moving, always strengthening, always ready to be put on display in our lives.

✷ Which characteristics of the Holy Spirit are the most familiar to you? The least?

✷ Look up each verse below and note how the Holy Spirit personally works in you.

John 14:26

Romans 8:26

Galatians 5:22–23

Isaiah 11:2

Acts 1:8

2 Corinthians 3:17

With all the powerful work the Spirit can do in our lives, the Enemy can't stop God, but he will do everything he can to distract us. His end goal is to disrupt the Spirit's work through confusion, diversion, misunderstanding, and any other evil tactic he can employ. This is war. It's critical for us to stay engaged with our eyes open and able to respond to the Spirit's prompting.

One night I had a prophetic dream. I was in a church without a pastor present, and a man went onstage and asked if someone had a message and a willingness to preach. I held up my pink Bible and, waving it, said, "I do! I have something to say!" I told my husband in the morning, "I think I am going to be somewhere and be asked to speak without warning." It felt like a holy heads-up, and I prayed I would be ready when the moment came.

Two months passed and I was attending a conference. I didn't have any speaking responsibilities, but I knew the organizer. The opening evening, she found me during worship and whispered that the speaker for the night couldn't arrive on time, and asked if I would be willing to fill in. *Yes!*

I was delighted and went backstage to prepare. Ten minutes before I was to walk out, the speaker miraculously showed up. I was crushed, more from disappointment I hadn't heard God correctly than from not sharing, but nonetheless I was sad.

I forced myself to sit in the audience and listen to what the rightful speaker had to share. I knew it had been herculean for him to get there, and I was curious about a God who helped him and who also had a plan B. Surely He didn't wonder if he'd make it?

�֎ In retrospect, which of your dreams have turned out to be prophetic? How can you be more attuned to your dreams?

That night, lying in bed, I wondered what lesson I was to learn. Finally letting go of what would've been a really good story, I prayed myself to sleep.

The next day, I was in a seminar when the director of the conference texted, "Sorry to do this to you again, but our main speaker tonight is caught in Atlanta with a bad storm and can't make it. Are you still willing to fill in?" I smiled as I texted my yes. The story God wanted wasn't the fill-in speaker; it was the conversation we'd had the night before about disappointment and issues of timing. God was asking me to exercise my muscle of "still willing." Am I "still willing" to give, go, speak, offer, care, etc. when the timing isn't my own?

✖֎ What do you sense God asking if you are "still willing" to do?

Connection to God and others can be broken through shame. It serves as a disconnector, isolating us when we need others most. It holds tension in relationships and causes us to hide, for fear that if someone *really knew* us, we'd be rejected. Since healing happens in relationship, it's the Enemy's chief goal that we don't act or live in community. He uses shame as a silencer, and without Christ's intervention, it would be an effective tactic to prevent attachment to one another and the Lord.

When we let others into our lives, or stories, through relationship, it's important to learn to balance the impact. We live within stories we're telling

ourselves, but we are not the only authors of our stories. We constantly interact with parents, siblings, coaches, friends, teachers, spouses, employers, children, even strangers, and their versions of our worlds influence the way we understand our unfolding narratives. It's up to us to decide to what degree we will allow them to shape our stories if they are based in shame or try to separate us from God.

�֎ Whom do you let speak into your life? How is that person telling his or her own story through your life?

✶ Our stories begin with the stories of other people—some beautiful and some tragic. What are the earliest stories you remember, and how have they been absorbed into your narrative?

Some people laugh when I give God credit for seemingly silly things—like on-time deliveries and good weather—as if it wasn't God. But I think quite the opposite. I imagine He does much more than I am aware of. I can get into my day, operating on my own strength, using my own reason and resources, and at some point, I get sloppy or wear out. Only then do I become aware of my need for Him. And He never wears out; He's ever-present, picking up the pieces and guiding, putting His power and protection on display. I can be oblivious to the Enemy's tricks, and he loves that, so he can slink around without my fighting him off. I can be equally oblivious to God's working, and that's just as dangerous. I am working on the throughout-the-day kind of regular conversation God designed us to have with Him.

✺ How can you be more aware of God's movements throughout your day?

Lord, help me to be more aware of You than I am aware of myself. Teach me to listen and to obey the Spirit's prompting inside me. I want to see You more clearly. Amen.

DAY 12

What does the Enemy want? He wants to mess with my body and ruin my identity.

I was in an Uber the other day making conversation with the driver, asking what she had going on the rest of her day. She told me of a pain-management appointment she was taking her mother to later that afternoon. I felt conflicted: I could either say something innocuous or initiate something spiritual. I decided to ask her if I could pray for her mother there in the car. I knew a couple of things could happen: her mother could be healed, the daughter could be heartened, and I could be encouraged for obeying a prompt. I don't know how it turned out for her mother, but that's not the point. Whether she was physically relieved of her pain or not, I can always confidently pray against the Enemy taking advantage of someone who is physically compromised.

When I hear of someone's physical ailment, I often wonder how much of it could be spiritual. Sometimes when I have the courage to initiate prayer, I see healing—headaches and dizzy spells that end up being more spiritual than physical. Other times there is an infection, or root cause for illness, as a result of living in a broken world, and I hope my prayers for bodies to respond well to treatment or wisdom for the doctors expedite healing.

✵ When was the last time you prayed in person for someone's health crisis? What was the result for that person? For you?

When is it spiritual and when is it simply medical? Can we know if an illness is medically based or spiritual? It's *always* spiritual. Even if the Enemy didn't cause someone to become ill, he will use it. We can pray toward the spiritual relief of anyone we encounter who is physically hurting. How or when God answers is not for us to measure. However, I know He doesn't like it when we are sick because He promises one day "'He will wipe every tear from their eyes. There will be no more death' or mourning or crying or pain, for the old order of things has passed away" (Rev. 21:4).

Jesus healed a woman who could not straighten herself. He said in Luke 13:16, "Then should not this woman, a daughter of Abraham, *whom Satan has kept bound for eighteen long years*, be set free on the Sabbath day from what bound her?" Jesus confirmed Satan messes with our bodies.

✵ Write out Acts 10:38. Whose power were the sick people under?

Since spiritual forces are at work against us, prayer over a hurting body is always appropriate. The Enemy wants to mess with our bodies, because at the very least, it requires energy from us we now can't expend elsewhere. In addition, it confuses and discourages, which our adversary loves. Does it seem like we see patterns of enemy attack on a person or a family physically? Yes. I am committing to bolder prayer intervention for those I love who fall ill. For binding the Enemy in the name of Jesus and asking God for complete healing. We have authority as co-heirs with Christ (it's our identity), and He tells us to

use it. "Is anyone among you sick? Let them call the elders of the church to pray over them and anoint them with oil in the name of the Lord" (James 5:14).

✵ How does understanding our identity as God's kids impact how we pray for healing?

Read Luke 11:11–13: "If a son asks for bread from any father among you, will he give him a stone? Or if he asks for a fish, will he give him a serpent instead of a fish? … If you then, being evil, know how to give good gifts to your children, how much more will your heavenly Father give the Holy Spirit to those who ask Him!" (NKJV).

✵ What good gifts have you seen Him give you in response to a prayer?

God says our identity is found in Him, but the Enemy wants us to wear our experiences as if they are our identities.

A child of an alcoholic.

An unwed mother.

A juvenile delinquent.

A liar. A gossip.

A cheater.

This way when we want to step out, or step up, we feel held back by who we are, or were.

Every time I am prompted to speak up, I sense God's fire in me. This is *chutzpah*, the Hebrew word meaning "utter audacity, nerve." It's bold, compelled to act … Fire is better than "sparkle." Our culture applauds sparkle,

but fire and substance are far more compelling and pleasing to God. Talent and IQ mean nothing without fire.

✡ Where do you need to repent for admiring sparkle over substance?

✡ In Scripture, the widow knocking on the door puts *chutzpah* on display. What other biblical characters act with utter audacity and nerve?

The Enemy whispers that our identities are wrapped up in prosperity and success and we should pursue them at all costs. God teaches in Joshua 1:8 that prosperity and success are given when we live His way. "Keep this Book of the Law always on your lips; meditate on it day and night, so that you may be careful to do everything written in it. Then you will be prosperous and successful."

I love a good class or article about strategy, innovation, and disruption and agree there's a place for business acumen, but don't ever place it over faithfulness. God doesn't count like we do. Instead, He honors boldness and obedience, born from security in who we are.

✡ What attributes or experiences do you assign to success? Who do you know that's successful? What makes you think they are?

There's a rabbinical saying, *Plan one thing every day you can't do without God.* That's what is needed to fight off the Enemy: I need to make it a habit to try something the world says I can't do, then give God the glory and make Him the star when it happens. He loves to come in to rescue saints in over their heads for His name's sake.

✸ What is something you sense God stirring in you? It might feel big, like something you couldn't do on your own (forgive someone, give something away, say yes to an opportunity, stop a bad habit, share your faith, etc.).

✸ Make a list of three things you couldn't do without God. (Who, what, when, where, why.)

EXAMPLE: Forgive my friend

Who: Jennifer
What: Comment that hurt my feelings
When: Last week
Where: In front of others
Why: I'm not sure
Prayer/Invite God in: Lord, teach me to see Jennifer the way You do. Help me to let go of hurt feelings and love her unconditionally. Amen.

#1:

Who:
What:
When:
Where:
Why:
Prayer/Invite God in:

#2:

Who:

What:

When:

Where:

Why:

Prayer/Invite God in:

#3:

Who:

What:

When:

Where:

Why:

Prayer/Invite God in:

✺ Write out 1 Timothy 4:12 below.

I can allow someone to look down on me because I am younger, older, richer, poorer—you name it—and let it limit me. This is falling into a sort of orphan spirit, when we operate without truly understanding the depth of love, acceptance, and identity that come with being adopted by our spiritual Father. Or I can identify as God's kid, and now the sky is the limit. That limitless, I-can-do-all-things-through-Christ mindset terrifies our adversary. Satan wants us to be held back or down, so every chance, in every

conversation, using all of his tricks, he will tempt us and lie to us until we believe we are anything but redeemed.

✵ Are you understanding and embracing your place in God's family?

Take a look at the following descriptions of an "orphan spirit" contrasted to being "God's kid," and circle the words or phrases that resonate with you.

✵ The orphan spirit operates out of self-doubt, envy, or rivalry and serves God to *earn* His love. It tries to remedy its deep disconnection through work, relationship, and indulgence, which can result in addiction. It is driven by achievement and the recognition of it. The orphan spirit uses people for its own purpose, insists on its own way, and operates with anger. It has a poor self-image and finds significance in material possessions, appearance, and accomplishments.

God's kid is grounded in and rests in the love and affirmation of the Father. He or she functions out of love and blessing and serves God out of a sense of acceptance and favor. God's kid seeks the presence of the Lord for comfort and joy and finds purpose in a calling and mission. He or she serves people to bless the kingdom and trusts God's sovereignty for his or her future.

> Lord, help me to see what You see! I want courage to do all You
> are asking of me. I want to know You in the deepest of ways.
> Give me eyes to see and a heart willing to act. Amen.

COMBAT
TRAINING

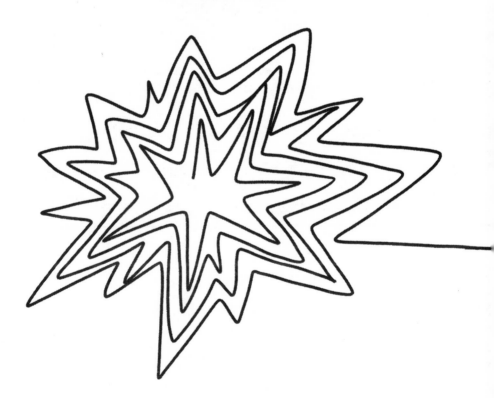

COMBAT Explained

In order to fight, we need to orient ourselves, remember our weapons and tools, and punch first. The Devil has nothing new up his sleeve. He will sneak up on us in all the ways we know he does. Let's go looking for him and proactively declare our authority in Christ.

My daughter was recently married, and in advance of the ceremony, Todd and I sat down to brainstorm how we'd seen the Enemy use sabotage in our lives and covenant events like marriage ceremonies. Then we worked out a plan to be spiritual *initiators* and prepared ourselves, our family, and even our home for attack. It strengthened our faith in Jesus, confirmed our sense of fellowship and co-mission, and protected the family we've been called to lead. When one of us was feeling weak, there was a platform to confess it—first to Jesus and then to each other.

COMBAT is an acronym designed to be memorized so when you find yourself in the middle of a hard conversation, a threatening situation, or a sleepless night, you can walk through these six steps. The result? Empowerment rather than vague anxiety or spiritual defeat. We'll spend the next six days learning how it works and putting it into practice.

C Confess your sins. It's the most critical step in being spiritually aggressive.

O Observe which tactic. What sin is making you vulnerable right now?

M Measure the impact. On what fronts is the Enemy attacking?

B Believe the Bible. What is the Truth, and how does it set us free?

A Aim your fist. Should you use prayer? Praise? God's Word?

T Throw the first punch—and experience victory.

DAY 13

C: Confess Your Sins

What does the Enemy want? He wants me defensive instead of humble.

Each day, as I approach every situation and conversation, I try to remember to ask: *What is happening here that I cannot see? How might the Enemy want to advance? How can I frustrate his plans instead of cooperating with him? What's next?* No matter how I answer those questions, my next step to adopt a posture of humility is always the same: confess my sins. We prepare adequately for spiritual encounters by first confessing and grieving our sin. This act deposits copious amounts of grace into us and fuels us for battle.

My relationship with admission of sin was rocky for a long time. I was, and still am, way more comfortable justifying my sin than confessing it. There always seems to be a good reason to say, do, or think what I am. Everything changed after I participated in a study where the focus was on sin confession. We would start with vulnerably sharing our thoughts. Sins like judgment, jealousy, and lust were revealed, and the more we named ours, the less we paid attention to each other's. There was such freedom in not feeling like I had to posture myself to look good or try to control anyone else.

✣ What does 1 John 1:9 teach us about confession?

Resolved to no longer put lipstick on a pig, I found myself motivated to face the consequences of my thoughts that were not centered on God. I realized that when a thought becomes almost obsessive, just running around in my head, it's most likely not authored by God. Truths freely flow, but then they settle, even when they are hard. Lies shut down our minds, taking us into stasis, and we could use words like *trapped*, *frozen*, and *stuck* when describing them. They work us up, and we feel the opposite of settled. Once I could see a sinful thought as a lie, I could walk through the confessional steps to get rid of it. Then I was ready to battle the Enemy and not myself or someone else.

Proverbs 28:13 says, "Whoever conceals their sins does not prosper, but the one who confesses and renounces them finds mercy."

✣ Which sins are the easiest for you to confess? The hardest?

I crave more self-awareness. What does daily confession look like, and how can practicing it satisfy my emotional fatigue like no treat I might give myself? How can I tell the truth when I'm afraid? Or sad? Or anxious? Could relationships in my life improve through vulnerability and confession?

Todd and I were sharing a meal with friends when the topic of grief came up. The wife's counselor said grief was like poop: we need to do a little every day or else we risk becoming emotionally constipated. I started wondering what I was preferring to ignore rather than pass. It is biblical to grieve our sin. We read in Isaiah 63:10, "Yet they rebelled and grieved his Holy Spirit." After denying Christ three times, "Peter was grieved" (John 21:15–19 ESV),

and Ephesians 4 warns not to "give the devil a foothold" (v. 27) and "do not grieve the Holy Spirit of God" (v. 30). Owning up to our sin is paramount to this process. We walk into stories blinded by pride if we lack self-awareness of how our sin impacts ourselves and others.

Another friend of mine is convinced, although she has no proof, that her husband sinned against her. They have fought about it, separated, and are now fighting about how they are fighting, instead of confronting the issues themselves. I have encouraged her to break their standoff by confessing her role in the story, but she won't. She's fixated on how his actions were worse, and the battle between them rages on. Unfortunately, we can predict with stunning accuracy the trajectory of that situation if neither party grieves their responsibility for it.

It's a sign of maturity to go first. Being humble and forgiving others are some of the most aggressive spiritual battle steps we'll take. They pack a power-ful punch against an enemy who delights in our division and stokes our pride. They demonstrate we are looking more to God than to others. Grieving our sin, or confessing our wrongdoing, comes not from what someone is or isn't doing right by us, but instead from understanding what *God* has done. Ephesians 4 goes on to say, "Get rid of all bitterness, rage and anger, brawling and slander, along with every form of malice. Be kind and compassionate to one another, forgiving each other, just as in Christ God forgave you" (vv. 31–32).

Again, we are trained for spiritual encounters by confession. This indwells us with abundant grace and readies us for battle. Was disappointment or envy, competition or pride building within stories I didn't like and couldn't control until I was literally exhausted and unable to spiritually fight?

During the season my stronghold of pride was being broken through the study of sin, I became brutally honest. I began with just myself and God. I would say aloud or write down statements like these:

- I am afraid they think I am better at something than I really am. I might disappoint them.
- I want something that isn't mine. I will delight when someone else enjoys it.

- I am anxious about (this child's) future. I can't control what happens to (this child).
- I am sad … or I am mad … or I am …

Soon, instead of bringing shame (*I can't believe I am feeling/thinking/ wanting this*), the confessions I would've rather not made, when confessed, brought lightness. My friend's counselor was right—it was stinky coming out, but it was necessary. Confession began to look like grieving (a broken heart over where I had fallen), and grieving began to look like confession (sorry, Lord, for longing for what *isn't*).

✵ What do you need to give over to God to carry? Make a list around the hands below, symbolizing handing them off to God.

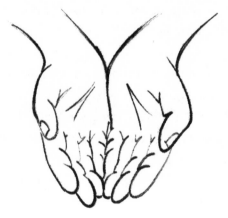

With all my grieving and confession came several benefits I wasn't expecting. The first unintended blessing I experienced was that of capacity, which can increase my impact for God's kingdom. When I am not carrying what isn't mine to carry, I have more room in my heart, mind, and hands to hold what God entrusts to me. A second result that I want to testify to is the freedom that results from confession. I used to think it was just freedom felt by me as the confessor, but my friends—my front-porch accountability people—noticed the changes happening in me when I acknowledged my own sin, received God's grace, and then had plenty to pour out on others around me. I was less controlling, less judgmental, and far more grace-filled

with others. Why? Because I was, and still am, growing in my understanding of how God has forgiven and extended grace to me.

Confession is just the first step in COMBAT, but unless you take the risk and humble yourself, the rest of the battle is already lost.

✻ Read 1 Corinthians 11:23–29 about the purpose behind the Lord's Supper. Take Communion today, either alone or with someone who is special to you. Consider what the practice means and how you can incorporate it more regularly into your life.

> *Lord, I want to confess my sin and make room for Your Spirit.*
> *Help me have the faith to overcome what my flesh struggles to*
> *keep behind the door. I give You the glory. Amen.*

DAY 14

O: Observe Which Tactic

What does the Enemy want? He wants me to be oblivious.

In combat, the US military uses the abbreviation OODA developed by strategist Colonel John Boyd. Short for *observe-orient-decide-act*, this recurring cycle shapes an approach to process an environment and react in an attack. The OODA loop shows that prior to making a decision (*decide*) on what to do (*act*), a person *first* needs to gather information (*observe*) and then determine what it means (*orient*). Spiritual warfare is no different. Observing the Enemy gives us insight into his patterns and a tactical advantage when facing a fight. Anything he can do to prevent us from gathering this intel keeps him in the dark (so to speak).

Our adversary delights when we expend energy to make ourselves feel comfortable. If I am looking at me, then I am not looking at him. If I am concerned about my well-being, then I am not aiming to be sacrificial or bold. How does he use this striving to his advantage? He lulls me into believing what I *want* will satisfy what I *need*. But I can't fix what God wants to heal, and He wants to heal my brokenness (before it gets exploited).

✵ What is something you are trying to fix right now, on your own, that God may want to heal?

Every story, no matter how painful, is an old one: Friends misunderstanding each other? Marriages strained under pressure? Temptation leading to addiction? Rebellious children? Churches splitting? Lust leading to perversion? There's only so many ways you can rearrange sin. We see these same patterns in Scripture, and from them we can learn how Satan will strike. He's actually pretty predictable: he looks for our weakness, then bites. Afterward, he attacks where we are wounded until we're debilitated and the fight is out of us.

�֎ Which weakness of yours does he typically attack?

The secret sauce isn't really that secret. While we say yes to Jesus, we have to say no to Satan. Yes, Jesus, I believe Your ways are best. I will forever be on this journey in pursuit of You. No, Satan, I see your traps, and no matter how attractive they look, I will walk away.

I am learning to see temptation for what it is: the beckoning finger of our enemy luring us to walk into traps ultimately designed to hurt us. When I see temptation and face it head-on, I save myself future pain. What if we looked like a tough opponent to our enemy, instead of an easy target? Might he leave us alone? Or at least the battle wouldn't be so lopsided.

We've been studying the many tactics the Enemy uses in order to be better informed and equipped for his lazy tricks against us. Of all the ways Satan wants me to fall, how can I recognize which scheme he is employing? It requires us to recognize our sin, listen to our spiritual intuition, and be sensitive to the Spirit's prompting.

✖ In the following list, check which tactic(s) the Enemy has used to try to trip you up within the last week. (Jot down the specific instance to the side if you'd like a better visual.) Circle the areas where you've seen victory.

- [] Pride
- [] Isolation
- [] Selfishness
- [] Discouragement
- [] Fear
- [] Disorientation
- [] Dimming my light
- [] Weary
- [] Judgmental
- [] Oblivious
- [] Numb
- [] Anxious
- [] Lost identity
- [] Distracted with pleasure
- [] Shame
- [] Ignorant of Holy Spirit's power

If I go about my day, oblivious to what he is doing, I am no threat. If I choose comfort over conflict, I am not advancing anything other than my own agenda. God gave me a role in this spiritual war; I am not a pawn. My voice can declare God is sovereign and we are victorious. When I use the power God gives me, His kingdom advances. I am not somewhere merely holding the line, bracing for an attack. I am moving boldly and unharmed "among the fiercest powers of darkness, trampling every one of them beneath [my] feet!" (Ps. 91:13 TPT).

Satan hates God, and since we are God's kids, Satan wants to hurt us, knowing this will also hurt God. What if instead of trying to outrun him, or hide from him, or ignore him, I look evil in the face and say, "I will go to war with you before I allow any ground to be taken."

✵ What skills do you need to develop to effectively fight Satan's attempt to ruin your life?

Paul teaches us in Ephesians 6 that this *will be* a struggle; it's real. There is no opting out or burying our heads in the sand. He says evil may come, but we can we stand against it.

✤ Read Ephesians 6:12–13 below. Underline what else we can know is true.
> For our struggle is not against flesh and blood, but against the rulers, against the authorities, against the powers of this dark world and against the spiritual forces of evil in the heavenly realms. Therefore put on the full armor of God, so that when the day of evil comes, you may be able to stand your ground, and after you have done everything, to stand.

✤ The full armor of God is critical to face the various ways Satan comes against us. After each piece of armor named in the verses below, write how it will specifically aid you in battle.
> Stand firm then, with the **belt of truth** buckled around your waist,
>
> with the **breastplate of righteousness** in place,
>
> and with your **feet fitted with** the readiness that comes from the **gospel of peace**.
>
> In addition to all this, take up the **shield of faith**, with which you can extinguish all the flaming arrows of the evil one.
>
> Take the **helmet of salvation**
>
> and the **sword of the Spirit**, which is the word of God. (Eph. 6:14–17)

We are in a constant war, so after **confessing** our sins and **observing** how the Enemy is attacking (and now that we're dressed for battle), let's measure his scope. What and who is he aiming to hurt?

Lord, teach me to be alert to enemy movements. I want to stand firm and fight wisely. I am praying here now for our family and those still lost. Amen.

DAY 15

M: Measure the Impact

What does the Enemy want? He wants to get more mileage out of my sin.

The Enemy has this sneaky trick where he can use one person's sin to impact multiple people. Our choices can result in collateral damage. Here are some examples:

- A husband and wife fight. Their sin impacts not only each other but also the child who is listening and now feels confused, scared, and unsettled. A friend hears the story from one of the spouses and might judge the other spouse. In just one moment of marital disconnection, decisions are made, accusations are spoken, and damage is done.
- A friend gossips. The one who sinned through gossip is damaged, the listener is harmed, the one who was gossiped about feels loss, and testimony and trust are destroyed.
- A child rebels. This choice impacts the child, puts stress on a marriage, sets a bad example for other siblings, causes others to judge, and costs time and money that

could be invested elsewhere. In addition, it stirs up doubt, discouragement, and shame.

Satan doesn't even have to work that hard; he can set something in motion and our sinful natures will take it from there.

� Write out John 8:35 below.

Sometimes sin begets other sin, and once we get started, it can be hard to stop. Other times sin halts all activity, and unconfessed sin can create a stasis. The Enemy knows both are damaging. When we feel caught or ashamed, we can get stuck, and an inactive Christ follower is as good to him as a rebellious one.

✦ What happens when you recognize your own sin? Do you typically double down or freeze?

✦ Can you recall a situation when one sin on your part impacted many?

Sometimes we can erroneously believe that if our sin wasn't witnessed by anyone else, it only impacts us and no one will even know. "But if you will not do so, behold, you have sinned against the LORD, and be sure your sin will find you out" (Num. 32:23 ESV). The truth has a way of coming to light. Acting in sin, either openly or secretly, hurts us and those around us. This is

Satan's great delight and why he applies pressure to our weakness. If we fall, the events we set into motion wreak havoc on the kingdom.

Todd and I were building a house to fit our unusually sized family—a mostly fun process. One night I came home and he was looking at pictures of bathroom fixtures, which confused me because we had already selected everything required.

"Do you want to change something we ordered?" I asked, innocently.

"I am thinking we need to add a bathroom to the guest room," he stated, as if already decided.

"Why?" I challenged. "We have plenty of bathrooms."

"I think our guests, especially the long-term ones, will like having the privacy," he countered.

And we were off. We started talking about bathrooms, but before long we were arguing about his mother and past conflicts, and I was angry. We had just learned in a trauma training at work that anger, in all its forms, is a secondary emotion. When we are angry, we are actually afraid. I didn't feel afraid, and I wasn't even thinking about that training. I was focused on winning an argument against Todd that we didn't need a bathroom in the guest room.

Todd had more composure in the moment and gently reminded me of the teaching. "Beth, you seem angry. Remember? That means you are fearful of something. What are you afraid of?"

I paused longer than I would like to admit. Taking a deep breath, I knew my fear and confessed, "I am afraid we can't afford it."

He quietly slid some papers in front of me and said, "Look at my calculations. We can definitely afford it, or I wouldn't have brought it up."

With my fears relieved, my anger dissipated. "Okay," I said and smiled, "then I'd like brushed nickel."

Satan has gotten ridiculous mileage out of the simple trick of causing fear. He wanted Moses afraid of Pharaoh and Elijah afraid of Baal. He tried to scare godly women like Mary, Esther, and Hannah. He even tried to scare Jesus in the wilderness.

✳ When was the last time you were angry? Can you dig down to identify what was scaring you?

✳ Think back over the last month or two and complete the two columns "I was angry (or irritated/frustrated) about …" and the reason was "I was afraid of …"

I WAS ANGRY ABOUT …	I WAS AFRAID OF …

When we can address in real time the struggle we are facing, the impact range of our sin can be minimized. If we allow our emotions to run out of control, then we multiply Satan's efforts (e.g., fighting about how we are fighting rather than the original dividing issue). If the Enemy can keep us afraid (one of his all-time favorite and most relied-upon tactics), we will sit in our anger. Sometimes anger is loud and abrasive and brings lots of collateral damage with it. Other times anger is passive and quietly creates distance between whoever feels threatened. Either way, fear destroys relationship and opportunity.

I can be afraid due to the state of my health or finances and then take it out on my child or through my driving. I can be afraid I am not enough, or that something isn't going to change, and that quiet anger may feel like rage. They say women don't go through a midlife crisis, that instead we enter an "age of rage" when we wonder if all of life has been about the needs of others. The antidote to a questioning season isn't medication or taking up a new hobby. It isn't changing husbands or picking up a bad habit. The answer is addressing our quiet (or not-so-quiet) fears regarding significance and remembering we are on a journey of obedience, not accomplishment.

�షⵣWhat is your typical "blast range" when you sin (i.e., who tends to feel it)? How quickly do you recover?

✷In the list below or directly on the following bomb graphic, describe a moment in the last week when you have sinned.

The situation:

Primary impact felt by:

Secondary impact felt by:

Label the multiple hits the Enemy can have on any given situation.

secondary

primary

Lord, help me to see my sinful choices and stop them so I don't cause others to fall. I want to be effective in kingdom construction, not destruction. Show me what's at stake when I sin. Amen.

DAY 16

B: Believe the Bible (Truth)

What does the Enemy want?
He wants me to believe his lies.

As the Father of Lies, the Enemy wants us to believe his deception. It's crucial for us to stand firmly in the truth found in our loving Father's Word. Can you recognize a lie when you hear it? Answer each question: true or false.

- When I sin, I get what I deserve.
- God will only come for me if I ask correctly.
- God helps those who help themselves.

All of those are false. Paul writes we are to "take captive every thought" (2 Cor. 10:5), "set [our] minds on things above" (Col. 3:2), and "renew our minds" (Rom. 12:2). Repeatedly, he reinforces spiritual discipline is first worked out in our heads, and then our feelings follow. I get myself into trouble when I rely on feelings or my to-do list as a thermometer for my spiritual health. If I only spiritually engaged in this war when I *felt* like it, I wouldn't be much of a warrior.

�překWrite out Hebrews 4:12 below.

I was so over the fighting. I had been wrestling with one of my foster daughters over the subject of appropriate clothing choices. "Go back into your room and change out of that miniskirt," I told her. "You can't go to school like that—" She slammed the door. I knew what was next; we watched this channel yesterday. She'd emerge in something I had bought her. I'd smile and tell her she looked cute. She'd stomp out the door, where I knew as soon as she turned the corner, she'd pull off the clothes I approved and reveal the micromini she had on underneath.

It was just one of *many* hills we were dying on.

I sought the counsel of a psychologist. He watched us for a few days and then drew a tree for me, labeling it in three parts. "Beth," he started, "I want you to imagine the foliage of the tree as the attitudes and actions of your foster daughter. It's the part you see and are reacting to, but it's not personal. Those attitudes and actions spring from her 'trunk.'"

He labeled the trunk on the paper "self-image" and continued, "This is what feeds her attitude and actions. It has been built from many experiences and over a long period of time." I nodded; he was making sense so far. "The trunk grows from the root system, and it represents her understanding of truth—specifically God's truth.

"The problem is, every time you talk to her about her attitude and actions, you're cutting off the top of her tree. I don't know how much you understand horticulture, but every time you cut off a branch, it grows back twice as strong.

"Her decision to dress inappropriately is directly linked to her self-image. She doesn't see herself as having value. She is worth something only when she is herself, *plus* a short skirt. Your comments to her are trimming her branches, when what you are dealing with is a trunk issue. Her self-image is linked to her root system, which is embedded with significant lies. The garden of her heart requires tending, and she must pull out the lies if you want to see growth and healing. She's less in need of behavioral correction or redirection and more in need of an infusion of God's truth.

"Here's what I want you to do," he went on. "Spend the next several months just focusing on the roots. Fill your language with what's true about God. Tell her what's true about her. Meanwhile, don't address her attitudes or actions *at all*, unless she is going to hurt herself or someone else."

I had been tracking with him until this point. "At *all*?" I managed to squeak out. "Not 'Did you do your homework?' or 'Get off the phone,' nothing about internet usage, curfew, clothing, dishes, laundry, eye rolling, *nothing*?"

I honestly wasn't sure I had it in me.

But desperation is a powerful motivator, and as best as I could, I spoke to her only in statements reflecting God's truths for weeks on end. It was like a foreign language. I hate admitting it was harder than I wanted it to be.

She would come home telling me how someone provoked her with a nasty comment at school, and I would say, "Regardless if they see it, you have incredible value and are wonderfully made." She would lament that everyone had better spring-break plans than she did, and I whispered, "God has big plans for you, full of hope." My tongue practically bled.

However, something was shifting. I became more fluent in this language of truth and liked who I was around her. She didn't seem so poised to strike when I approached. She listened more intently when I spoke, and her reactions slowed while she processed my comments.

Months into this new practice, she surrendered to Jesus.

She and I are both *still* working out our faith with fear and trembling. As I saw fruit born in her life through the process of root pulling, I joined her by looking at the metaphorical garden of my own heart and how the roots there fed *my* self-image. I would've rather looked at just her tree, but she wasn't a project; she was iron scraping against my iron.

⁂ Next to the following tree illustration, label the branches with some attitudes and actions you'd like to change. Where did they come from? What do they say about how you see yourself? What lies might be deeply embedded in your root system that need to be pulled out?

A practice I've undertaken to soak in God's truth is to personalize verses. I insert my name in the verse, and it seems like God is talking to me.

Ephesians 1:5: "He predestined [Beth] for adoption to sonship through Jesus Christ, in accordance with his pleasure and will."

Romans 15:7: "Accept one another, then, just as Christ accepted [Beth], in order to bring praise to God."

Jeremiah 1:5: "Before I formed [Beth] in the womb, I knew [her], before [she was] born I set [her] apart; I appointed [her] as a prophet to the nations."

1 Peter 2:9: "But [Beth is] a chosen people, a royal priesthood, a holy nation, God's special possession, that [she] may declare the praises of him who called [her] out of darkness into his wonderful light."

✷ Pick a couple of your favorite verses and personalize them below.

Lord, help me to get to the root of why I act rebelliously. Teach me to see myself as You do. I want to believe Your truth over all else. I trust You. Amen.

DAY 17

A: Aim Your Fist (Scripture, Worship, Prayer)

What does the Enemy want?
He wants me to feel powerless.

We are not defenseless in a spiritual battle. We have been equipped with tools designed specifically for enemy destruction. Remember these truths:

- Jesus ministered for three years, then was crucified, died, and was buried.
- After three days, He resurrected and ascended into heaven, leaving us to tell of His greatness and live in His power.
- He promised He is in us, and with us, and greater things will be done through us.

Whoever believes in me will also do the works that I do; and greater works than these will he do, because I am going to the Father. Whatever you ask in my name, this I will do, that the Father may be glorified in the Son. If you ask me anything in my name, I will do it. (John 14:12–14 ESV)

✵ Write below what the verses above mean to you.

God promises to provide power to His kids for what we need. This is why we can look at our enemy and not flinch. Need to forgive someone? Feeling overwhelmed with grief? Battling an addiction or temptation? Experiencing anxiety or depression? Feel the need to control or perform? Whatever and however the Enemy is calling to you, we have gospel power available.

English evangelist Graham Cooke said, "You can tell the quality of someone's inner life by the amount of opposition it takes to discourage them."[5] I have been working on reverse engineering. When I am feeling discouraged, I know it's time to strengthen my inner life. How do I do that?

Read God's Word, worship, and pray. These tools are within my reach to fight the Enemy and cultivate a powerful, eternally hopeful inner life. To stand strong in my marriage, home, ministry, friendships, and life, I need to prepare daily for spiritual confrontation.

Tool #1 is God's Word. I will often listen to an audio version of the Bible while I am driving, walking, or working, and sometimes I sit with a journal and my heavy study Bible. On a hard day, I repeat what was earlier put to memory. Have you ever noticed that in the Ephesians 6 passage referencing the armor of God there isn't a sheath? That's because I am never to put away this sword. Regular ingestion of biblical truth isn't a step that can be skipped. It does everything: strengthens, challenges, comforts, encourages, emboldens, and convicts.

�シ How has the study of God's Word strengthened you?

Tool #2 is worship. Sometimes I listen to loud music in my car with the windows open and the wind on my face. Other times I put on instrumental worship and let the sound comfort me. Psalm 22 talks of the Lord inhabiting the praises of His people, giving us a certainty of His nearness. Worship doesn't have to involve musical notes. The Psalms teach that anything intended to honor God is considered praise, so we can praise Him while we

work or play. Worship is as much about posture as it is about song. It reminds me of His truth and our position in Christ.

Praise was critical to King Jehoshaphat's victory over the combined armies of Moab, Ammon, and Edom in the Judean wilderness. Knowing the armies were coming, he said, "We have no power to face this vast army that is attacking us. We do not know what to do, but our eyes are on you" (2 Chron. 20:12).

�²Have you ever felt like this—under attack and you don't know what to do? Where does God tell us to look?

Then Jahaziel the prophet said to the gathered assembly, "Do not be afraid or discouraged because of this vast army. For the battle is not yours, but God's. Tomorrow march down against them.... You will not have to fight this battle. Take up your positions; stand firm and see the deliverance the LORD will give you" (vv. 15–17).

The army marched toward the enemy, and "Jehoshaphat appointed men to sing to the LORD and to praise him for the splendor of his holiness as they went out at the head of the army, saying: 'Give thanks to the LORD, for his love endures forever.' As they began to sing and praise, the LORD set ambushes against the men of Ammon and Moab and Mount Seir who were invading Judah, and they were defeated" (vv. 21–22).

✶What role did worship play in their victory?

God used their praise as a weapon; it served to remind them of the hope they had in Him. They held on to the certainty of God's provision, and it carried them through to victory. Likewise, Paul and Silas in the Philippian

jail were "praying and singing hymns to God" when the earthquake struck and set them free in Acts 16:25–26. In moments when I feel overwhelmed, I play worship music and trust God hears my heart's cry to agree with His truth and fight, even when I feel incapable of moving forward with the fight.

�souch When has worship strengthened you?

Tool #3 is prayer. When we talk to God, He strengthens us and responds to our cries. This weapon isn't one size fits all. Sometimes I download my thoughts to God hurriedly, and I just need Him to hear me process. Other times I am crying out one word. It could be *help, save, deliver, wow, thanks, please, now!* Still other times I am silent in prayer but listening. This connection allows His power and peace to flow through us. Prayer brings peace, or *shalom*. The word *shalom* is made up of four characters that translate "destroy, authority, attached, chaos."

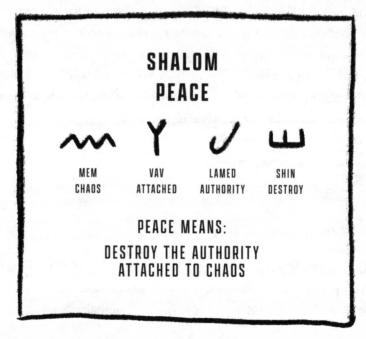

SHALOM
PEACE

MEM	VAV	LAMED	SHIN
CHAOS	ATTACHED	AUTHORITY	DESTROY

PEACE MEANS:
DESTROY THE AUTHORITY
ATTACHED TO CHAOS

Peace isn't passive; it's the outcome of a shared agenda with God to destroy the authority attached to chaos. "The reason the Son of God appeared was to destroy the devil's work" (1 John 3:8). When I sit with God in prayer, I feel His peace, knowing His presence pushes chaos out of reach.

✶ Read the following verses. How do these truths newly encourage you to pray?

> So humble yourselves before God. Resist the devil, and he will flee from you. Come close to God, and God will come close to you. (James 4:7–8 NLT)

> Look, I have given you authority over all the power of the enemy. (Luke 10:19 NLT)

> So we keep on praying for you, asking our God to enable you to live a life worthy of his call. May he give you the power to accomplish all the good things your faith prompts you to do. (2 Thess. 1:11 NLT)

> Contend, LORD, with those who contend with me;
> fight against those who fight against me. (Ps. 35:1)

It doesn't matter whether I whisper my prayers, write them, shout them, do them with others, say them in the morning—whenever and however I connect with God—talking to Him provides what I need to get through any new battle. When I engage in biblical practices, I see God deliver what I need: mercy, patience, self-control, love, peace, and joy. In the end, the result of that fruit in my life makes me grateful, instead of bitter, for the battles I face.

✯ For the season you are in right now, copy the following prompts onto a card and then complete them to act as an armory for battle.

Favorite verse:
Go-to worship song:
Best one-line prayer to destroy the authority attached to chaos:

✯ Take a look back at the life situation you saw the Enemy exploit (see the last question in Day 2). How could you aim an attack at the Enemy specifically for that story?

Lord, teach me to pick up these weapons and unabashedly face our enemy. I want to go to battle against him. Instead of him creating chaos, allow my use of these tools to draw me closer in relationship with You, resulting in peace. Amen.

DAY 18

T: Throw the First Punch

What does the Enemy want? He wants me to be timid.

We have **c**onfessed our sins, **o**bserved the Enemy's tactics, **m**easured what's at stake, **b**elieved only truths, and taken **a**im. It's time to **t**hrow the first punch, landing it exactly where we imagine will most frustrate the Devil's agenda. We don't have to wait until he strikes us first and then, wounded, try to defend ourselves. We can be proactive and thwart his attempts to take us out.

Punch-first thinking has changed how I approach *anything* hard. It mentally moves me from overwhelmed to proactive. It also invites me to expect that good will result from spiritual battle. We can erroneously believe if God is good, life should be also. But sometimes life is hard, and God is still good. For example:

- Todd and I are walking alongside a couple struggling in marriage. I know the Enemy will want us to disconnect, so he'll make us feel like we don't have anything to offer another couple if we can't figure it out ourselves. Our punch-first strategy is investing in our own marriage more intentionally during this season, so we have plenty of health to offer others.

- We have a son graduating from high school without a clear plan. My punch-first strategy is to remind him of what's true about him *before* the Enemy's whispered lies of shame can land.
- A friend spoke freely and her words offended me. The Enemy wants that insult to divide God's family. A punch-first strategy would be for me to serve the person who offended and ask God for the grace to do so. "'If your enemy is hungry, feed him; if he is thirsty, give him something to drink.' ... Do not be overcome by evil, but overcome evil with good" (Rom. 12:20–21).

Our adversary is counting on us falling back on our sin natures, so he constantly sets traps. When we walk around them, through them, or better yet, ahead of them, he is unsuccessful and we are victorious. This is the rhythm of grace we can live in and rest securely. "Let the beloved of the LORD rest secure in him, for he shields him all day long, and the one the LORD loves rests between his shoulders" (Deut. 33:12).

If I am struggling in a conversation to keep my thoughts pure, if I am tempted to do something I know I shouldn't, if I get pulled into a story without an easy answer, if I am overwhelmed with how messy something has become, I work my COMBAT plan. The more I use it, the easier and more natural it becomes. I know the result is intimacy with God and kingdom advancement.

Confess your sin. (Forgiveness brings freedom.)
Observe what tactic. (The Enemy has no authority in my life!)
Measure the impact. (He can't win twice!)
Believe the truth. (Trust and declare our authority as co-heirs with Christ.)
Aim your fist. (Worship, Scripture, and prayer are powerful tools.)
Throw the first punch. (Destroy the Devil's work!)

Together with Christ we can walk with conviction toward whatever or whomever or wherever we sense God leading.

�043 In what area of your life do you feel regularly attacked? What is one punch-first strategy you could employ? How would your plan frustrate the Enemy?

Take a moment to process a current struggle by using the COMBAT plan below.

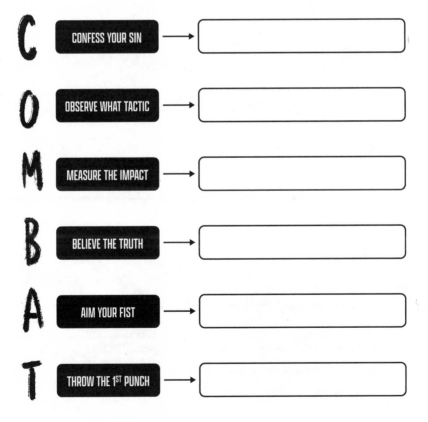

COMBAT requires a willingness to engage, to say yes, and to be bold. It's simpler to dodge an attack than to run headfirst into one, but when we delay facing our problems, we just compound them. When I sense God asking something of me, I say the word *hineni* to myself. *Hineni* is a Hebrew word that translates to "Here I am" or, more accurately, "Whatever it is you are asking of me, I am already in agreement of it." It's used eight times in the Bible, each a defining moment in a biblical character's life requiring decision, action, and resolution—saying yes to God. Examples include Moses saying yes when God called him to lead the Israelites out of slavery at the burning bush (Ex. 3) and Abraham saying "Yes, here I am" when God called him to sacrifice his son Isaac (Gen. 22).

�֎ When was a time you told the Lord yes?

✖ Is there a time when you regret you didn't say yes?

I want to have a spirit of *hineni*, but it requires listening to the Lord more than my present company and culture. I don't want to count costs or count myself out, but if God asks, leads, or prompts, I want to be ready to respond with *yes*. If I am too weary, I say no to God, when most of the time what has worn me out wasn't ever His idea!

There is one time in Scripture when the Lord says *hineni* to us:

> Is not this the kind of fasting I have chosen:
> to loose the chains of injustice
> and untie the cords of the yoke,
> to set the oppressed free
> and break every yoke?

Is it not to share your food with the hungry
 and to provide the poor wanderer with shelter—
when you see the naked, to clothe them,
 and not to turn away from your own flesh and blood?
Then your light will break forth like the dawn,
 and your healing will quickly appear;
then your righteousness will go before you,
 and the glory of the LORD will be your rear guard.
Then you will call, and the LORD will answer;
 you will cry for help, and he will say: [*hineni*] Here am I.
 (Isa. 58:6–9)

There it is, the explanation of my whole Christian journey: busy about His work, when I'm in over my head, I need Him to provide daily for what I don't have in natural reserves. Some days I ask for wisdom or discernment; some days for self-control or patience. I am *hineni-ing* my way through adoptions, friendships, tough assignments, marital conflicts, and the occasional health crisis. I want what He wants. I want to be battle-ready, not battle-weary. The Enemy is trying to convince me to be busy, while the Lord is calling me to be available. The difference will keep me from the dark waters of disaster.

�֎ What do you need Him to provide for you?

✶ What is the difference between busy and available?

Lord, help me to have faith and strength to stay in this battle. I want more than anything for You to hear my yes. Amen.

Do the Work

The following days show how to move forward, implementing into your life all you've learned thus far and sharing your fighting spirit and tactics with others.

DAY 19

Thinking Forward, in Patterns, and Preventively

What does the Enemy want?
He wants me to be ignorant of his ways.

I was speaking at a church in my city, where I had been many times, on something I had learned in Israel. I was excited to share the insight I had gained, and afterward I felt it had gone well.

The following week, I received a request to come into the church offices, where one of the staff members, whom I knew well, challenged my teaching and questioned its accuracy. I was stunned, hurt, and confused. I wish I knew then what I know now about how the Enemy will use things to his advantage, but I didn't, and as I sat there listening and absorbing, he landed a blow.

It's been a decade since that incident, and although I did the work in the immediate aftermath to show how I had come to my conclusions and was ultimately "cleared" of any heresy, the pain and shame of that moment stuck. Now when I open an email with a byline that reads "last week's message," my heart sinks. I can feel overwhelmed with dread that I have again been misunderstood. Almost without exception, those emails are full of encouragement; but even if I try to stack them up against that one incident, the punch still landed and now I have a bruise.

�֎ What's a situation that bruised you and left an extra sensitivity?

We each have moments when something uncomfortable happened and we weren't expecting it. Now, an innocent trigger can bring back unwanted and unresolved emotions. For some it's test taking, or first dates, or doctor's appointments. It can be a comment about your body, or intelligence, or upbringing, or children.

This is where I can learn to punch first, so my bruise not only heals but also can be used to my advantage.

> **Punch first:** I have a system where someone else checks my research before I present it. At first I did it for protection; now it's a step of strength.
>
> **Punch first:** I read challenges in the presence of safe accountability, where they either help me see through someone's agenda or gently correct me if needed. At first I did it for justification; now it's an act of sharpening.
>
> **Punch first:** I pray for the person who originally hurt me, asking God to heal him or her from whatever caused the confrontation in the first place. At first it was a prayer of obligation; now it's spoken with joy and affection.
>
> **Punch first:** I go into a meeting or a conversation with a plan: I will say what I am thinking. I might have it prepared in writing, and I will check for understanding. I don't want the Enemy to see any place where he can mess with me. At first it was a backup; now it's a leadership strength.

These are small steps I take to not feel like a victim, but instead a proactive warrior. Whether our bruises have to do with school, our in-laws, our body image, or financial strain, we can see clear patterns in our lives of how the Enemy attacks. He isn't creative, and if he's found an advantage in a certain place, he'll likely strike there again.

> We are afflicted in every way, but not crushed; perplexed, but not driven to despair; persecuted, but not forsaken;

struck down, but not destroyed; always carrying in the body the death of Jesus, so that the life of Jesus may also be manifested in our bodies. (2 Cor. 4:8–10 ESV)

Difficulties *will* come, brought on by

> our own weakness,
> someone else's poor choice, or
> the result of the world being broken, and our living life in
> a fallen creation.

We will experience shattered relationships, physical setbacks, spiritual attacks, and grief. It can be tempting to think "it" will all be better when circumstances change.

�帐 What's your "it"? That thing that needs to be resolved before you feel like you can embrace God's calling on your life?

I have my own "its." I can be guilty of saying:

> "When I feel better, then ..."
> "When this season is over, then ..."
> "When we have/get/go to _____, then ..."

But here's what reading the Bible tells me: in this world, *there will always be another battle.* From 2 Samuel 21:

- *Once again there was a battle* between the Philistines and Israel. David went down with his men to fight against the Philistines, and he became exhausted. (v. 15)

- In the course of time, *there was another battle* with the Philistines, at Gob. (v. 18)
- *In another battle* with the Philistines at Gob, Elhanan son of Jair the Bethlehemite killed the brother of Goliath the Gittite, who had a spear with a shaft like a weaver's rod. (v. 19)
- *In still another battle*, which took place at Gath ... (v. 20)

Make a timeline of the last year. Note some of the major battles you have faced. On the left side, mark where you saw victory, and on the right, mark where you suffered injury.

TIMELINE

• JANUARY

• JUNE

• DECEMBER

✨ Since the Enemy can be predictable and has no new tricks, review your history. Thinking ahead and looking for patterns, how might he attack you next?

✨ What punch-first strategies would give you the tactical advantage?

A military tactic known as "shock and awe" (technically known as "rapid dominance") is defined by the use of overwhelming power and spectacular displays of force to destroy the enemy's perception and will to fight. Harlan K. Ullman and James P. Wade are the authors of this strategy, and they identify four vital characteristics of rapid dominance:

- near-total or absolute knowledge and understanding of self, adversary, and environment
- rapidity and timeliness in application
- operational brilliance in execution
- near-total control and signature management of the entire operational environment[6]

Shock-and-awe strategies have proved successful in many US military operations, and the principles are the same in spiritual warfare. We have to know ourselves: our weaknesses and our histories. We have to know our adversary and then with rapid and timely application, attack him, remembering we are not alone in this campaign. God has sent His angel armies to join us.

God sends angels with special orders to protect you
 wherever you go,
 defending you from all harm.
If you walk into a trap, they'll be there for you
 and keep you from stumbling.
You'll even walk unharmed among the fiercest powers of
 darkness,
 trampling every one of them beneath your feet!
For here is what the Lord has spoken to me:
 "Because you loved me, delighted in me, and have been
 loyal to my name,
 I will greatly protect you.
I will answer your cry for help every time you pray,
 and you will feel my presence
 in your time of trouble.
 I will deliver you and bring you honor." (Ps. 91:11–15 TPT)

�帐 Insert your name into the above passage from Psalm 91 so you can refer back to it as your personal promise from God. (Example: "God sends angels with special orders to protect *Beth* wherever *she* goes …")

Lord, thank You for being my glorious Hero and sticking with me in battle. Give me a heart for healing and a mind for strategy. Amen.

DAY 20

Practicing Your COMBAT Plan

What does the Enemy want? He wants to catch me off guard.

As complicated as the Bible can seem sometimes, it can be boiled down to two words: *come* and *go*.

God tells us:

> come into relationship with Him,
> come to His table,
> come to His strong tower.

He's a relational God; He's always inviting us.
But He also sends us forth:

> go into the world,
> go into dark places,
> go make disciples.

Every time I go *in Jesus' name,* it costs me something.

We can be in a moment where someone is rubbing us the wrong way, or the Enemy is beckoning us into a trap, and in that moment our world is held in the balance. *Do I make right choices, stay on the path, call out to God, and receive His blessings? Or do I give in, give up, or worse yet, run to a poor choice, maybe feeling better in the moment but worse in the end?*

Throughout the day we face the decision: give in or fight back. COMBAT is a tool to mentally prepare, then engage in the battle. When I walk through the steps, I am more than ready to face the Devil and stave off temptation. The combination of my weakness (within), the world's temptations (around), and the Devil's lies (nearby) can create havoc and quickly derail God's plans for my life—unless I fight back.

The Greek word *sozo*, which is translated "saved" or "salvation" in the Bible, actually means three things together: "save, heal, and deliver." It's not just a onetime saving, when we went from darkness to light. It's God's response over and over again when we call on Him. It doesn't matter how relentlessly the Enemy attacks us, or how badly our sin has messed things up, God will never stop coming to our rescue.

As God is putting us back together, or touching places where we need healing, He will use all things together for our good—transforming either our circumstances or us in the midst of those circumstances. I use *sozo* all the time, calling on Him to bring His heavenly angel armies to battle on my behalf.

� *Sozo. Come for me; I feel overwhelmed.*

Write what is overwhelming to you. How could practicing your COMBAT plan help?

✴ *Sozo. Heal me; I am broken.*

Confess where you've been trying to fix something God would rather heal. How could practicing your COMBAT plan help?

✴ *Sozo. Deliver me; I am tempted.*

Admit where you are being tempted today to say, do, or think something outside of God's will. How could practicing your COMBAT plan help?

✴ *Sozo. Save me; I am lost.*

We can't do it in our own strength; we can't be free or fight without God's power. It doesn't come *from* us, but *through* us. Share with Jesus where you feel lost. How could practicing your COMBAT plan help?

I want faith-filled stories, ones where I knowingly partner with Jesus to see breakthrough and kingdom advancement. The Lord "trains my hands for war" (Ps. 144:1). I want to trust in His training and be ready for the war.

My job: keep saying *yes*.

Yes, Your ways are best.
Yes, I will go, sacrifice, share, and speak in Your name.
Yes, I trust You.
Yes, You are sovereign.

His power will never fail; it never runs out. Every day, I need power to: tame my tongue, have self-control, be generous, turn the other cheek...

Our yes plus His power will combine to write incredible faith stories in our lives. Will we get in over our heads? Absolutely. Will we forget and fall or be overwhelmed or need help? Yes, absolutely. But He loves to come in and save the saints who are in over their heads for His name.

OUR YES + HIS POWER = INCREDIBLE FAITH STORIES

What is something you can say yes to God about today?

"For the kingdom of God does not consist in words but in power."
1 Corinthians 4:20

> The LORD shall preserve you from all evil;
> He shall preserve your soul.
> The LORD shall preserve your going out and your coming in
> From this time forth, and even forevermore. (Ps. 121:7–8 NKJV)

This doesn't mean I will be shielded from hard stories. Instead it means, in life, I will be well-armed, not left alone, and always belonging to God. Hallelujah! No matter what comes for me, He holds my soul. God will not give away the very thing He created for eternity. The Enemy may mess with my body, my thoughts, my relationships, and my ministry, but he can never have my soul. That is in the hands of my Savior.

The following verses are the first of six times the Hebrew word *shamar* (which translates to "keep and preserve" or "guard and protect") is used in Psalm 121. The image is of a sheepfold. When a shepherd was out in the wilderness with his flock, he would gather thornbushes to create a corral in which to place his flock at night. The thorns would deter predators and protect the sheep from harm. In Numbers 6, the Aaronic blessing, it says, "The LORD bless you and keep you" (v. 24). He's a keeper and it's why we can stand and fight against an enemy.

> The LORD is your keeper;
> The LORD is your shade at your right hand.
> The sun shall not strike you by day,
> Nor the moon by night. (Ps. 121:5–6 NKJV)

The Hebrew word for "shade" is *tzel*, and we are encouraged to rest. God models this for us with the Sabbath day in creation. He wants us to retreat, rather than escape, the challenges spiritual battles bring. Growing up, my mom always said when I felt overwhelmed to go to the "911" verses in the Bible:

> Whoever dwells in the shelter of the Most High
>> will rest in the shadow [*tzel*] of the Almighty.
> I will say of the LORD, "He is my refuge and my fortress,
>> my God, in whom I trust." (Ps. 91:1–2)

We can rest here, be shaded, take a deep breath. This is the rhythm required in a lifetime of battles.

✡ What does your rhythm of rest look like? How can you spend more time under God's *tzel*?

When Psalm 121 says the sun shall not "strike you," the term used could also be translated "to hit, attack, or strike down." In ancient times, people thought the sun was the source of heat that "attacked" them by day, and the moon was the source of cold that "attacked" them by night. When God led His people in a pillar of cloud by day and a pillar of fire by night, He was sheltering them from the enemies of cold and heat in the desert. God will protect us from every strategy the Enemy will try to use against us.

The image of "shade" is often used to mean protection.

✡ What does Numbers 14:9 say about shade and protection?

✺ Who has provided *tzel* for you? List their name(s) under the tree.

Lord, I want to be quick to ask for sozo *and to understand what You are doing so I can join You. You are the one who saves. Train my hands for war. Amen.*

DAY 21

Sharing Your Walk and Fight with Others

What does the Enemy want? He wants me to feel alone.

I have always been fascinated with the parable of the shepherd who goes looking for the lost sheep in Luke 15. I am in awe of a God who doesn't look at the ninety-nine left behind and think He's doing pretty well. I often erroneously attribute human tendencies to God (fatigue, irritation, or in this case, meritocracy). Instead, God has an eye that has never left the "one" and that sees wherever it has scampered off to, either out of rebellion or in escape. He understands the entirety of its story with all its complexity and still without judgment.

We were all once that sheep around His shoulders when He brought us home. What happens then? When we spend time around the other ninety-nine, there can be friction. At its best, the good kind of friction we label as iron sharpening iron. At its worst, friction can cause conflict that divides families, churches, friendships, and marriages.

God set up our spiritual family so we would need one another. We need to confess our sins to one another, asking one another for prayer and accountability. "And let us consider how we may spur one another on toward love and good deeds" (Heb. 10:24). We need to be inspired by one another and go to one another for celebration and support.

✳ With whom in your spiritual family are you vulnerable?

When I'm vulnerable, I admit to fighting my own nature to be self-ish, independent, and judgmental when circumstances are uncomfortable. Exposure is risky, but the benefit of asking for help and releasing control far outweighs the cost. We cannot fight alone; together, we make up the temple of the Holy Spirit. "Don't you know that you yourselves are God's temple and that God's Spirit dwells in your midst?" (1 Cor. 3:16).

That word "you" in the Greek is plural, so it's like God is saying, "Don't you know that *all you all* are God's temple?" Together, when we live as God's kids, His Spirit dwells in our midst and our enemy isn't even a rival at that point—the fight is over; God wins.

All over the New Testament, God gives instruction for how His kids should act toward others:

> *Love one another, give preference to one another, honor one another, be of the same mind toward one another, do not judge one another, build one another up, accept one another, greet one another with a holy kiss, care for one another, serve one another, bear one another's burdens, show tolerance for one another, be kind to one another, do not lie to one another, comfort one another, encourage one another, spur one another on toward love and good deeds, do not complain about one another, confess your sins to one another, pray for one another, be hospitable to one another, clothe yourself with humility toward one another, have fellowship with one another ... (and that's not even all of them!)*

✳ Looking at the list above, circle which of these are the hardest for you to do. Underline which are the easiest.

God knows that when we act lovingly, we put our supernatural nature on display. We announce: I don't belong here; I have been redeemed. God partners with us to represent Him to others. "Each one will be like a shelter from the wind and a refuge from the storm, like streams of water in the desert and the shadow of a great rock in a thirsty land" (Isa. 32:2). He wants us to be shaded by Him, then in His name, shade others.

Todd and I welcomed a young woman, Dee Dee, into our family many years ago. She'd had various family arrangements, but once she joined ours, it felt like she'd been with us forever. On her twenty-first birthday, I was asking her questions about her birthday: Did she know what time she was born? How much she weighed? My questions were making her uncomfortable, but I pressed on, hoping she would get more relaxed as we continued.

Finally, Todd broke into the conversation.

"Dee Dee," he looked straight at her, "people make a big deal about where you are from. Who cares if you don't remember the answers to those questions. I don't think it matters where you came from; I think it only matters where you now belong." He pulled off his glasses and said with the solemnity of a judge, "You belong with us."

That was it. She felt settled after that, and almost everything changed in regard to how she interacted in our larger family. We had addressed this question once and for all, and now the Enemy couldn't get any mileage on the lie that she was unsheltered. We were providing her with shade, because God first shaded us. Let this question get settled for you once and for all: no matter where you've come from or what questions you still have about your life, you belong to God.

�轉 Write out John 1:12 below.

This truth can reconcile our questions and silence lies. We are God's kids, shaded by Him, and now commissioned. This life was never meant

to be lived in isolation. While fully dependent on God, we are to be interdependent with each other, living in a supernatural harmony that demonstrates to those still outside of God's family that we are citizens of another place. As you fight the Enemy, ask others to join you and celebrate their victories.

> The LORD your God is in your midst,
> A victorious warrior.
> He will rejoice over you with joy,
> He will be quiet in His love,
> He will rejoice over you with shouts of joy. (Zeph. 3:17 NASB)

> *Lord, I want to be a good spiritual sibling to others. Help me to see myself as interconnected into this larger family and to recognize the responsibility that comes with it. I want to look like You: a victorious warrior who fights off an enemy and lives in step with Your Spirit. Amen.*

I was at a conference in college, and the speaker told a story of a Rwandan man in the 1980s who had been converted to Christianity through a missionary. His tribe was opposed to his new faith and threatened him with death if he didn't renounce God. Given one last chance, he was told the next day would be his last unless he refused Christ. He stood strong and was martyred. Found among his belongings was a journal in which he wrote the night before he died.

This was the first time I heard his final writings, and I recall standing up spontaneously in the middle of its reading. I wanted my body language to reflect the *yes* I heard in my heart. Since then, I've reread it on days when I feel battle weary and need reminding that even when I am weak, in Christ I am strong. I want to give this spiritual brother of mine the last word in this guidebook on reflection and spiritual-war strategies. While

reading his commitment and willingness to die for our faith, may we be inspired this day to fight without relenting.

I'm part of the fellowship of the unashamed. I have the Holy Spirit's power. The die has been cast. I have stepped over the line. The decision has been made—I'm a disciple of his. I won't look back, let up, slow down, back away, or be still.

My past is redeemed, my present makes sense, my future is secure. I'm finished and done with low living, sight walking, smooth knees, colorless dreams, tamed visions, worldly talking, cheap giving, and dwarfed goals.

I no longer need preeminence, prosperity, position, promotions, plaudits, or popularity. I don't have to be right, first, tops, recognized, praised, regarded, or rewarded. I now live by faith, lean in his presence, walk by patience, am uplifted by prayer, and I labor with power.

My face is set, my gait is fast, my goal is heaven, my road is narrow, my way rough, my companions few, my Guide reliable, my mission clear. I cannot be bought, compromised, detoured, lured away, turned back, deluded, or delayed. I will not flinch in the face of sacrifices, hesitate in the presence of the enemy, pander at the pool of popularity, or meander in the maze of mediocrity.

I won't give up, shut up, let up, until I have stayed up, stored up, prayed up, paid up, preached up for the cause of Christ. I am a disciple of Jesus. I must go till he comes, give till I drop, preach till all know, and work till he stops me. And, when he comes for his own, he will have no problem recognizing me ... my banner will be clear for "I am not ashamed of the Gospel, because it is the power of God for the salvation of everyone who believes ..." (Romans 1:16)[7]

We read in Revelation that the Enemy will end up in the lake of fire, while we are invited to spend eternity in a new heaven and a new earth (Rev. 20–21). We don't have to wait until then to celebrate. Every time we experience spiritual victory, we are getting what C. S. Lewis calls "an inkling" of what's to come. I am hungry for it; I want to walk this place like I don't belong here. Join me. Let's gather an army of freedom fighters—kingdom advancers—fearless builders of the kingdom of heaven on earth.

Amen.

 Remember when we dropped a pin at the beginning of this journey? Take a moment and revisit the questions you tackled on pages 8–9. Let's see what has shifted over the last 21 days …

�֎ What do you believe about the Devil?

✷ How often do you think he tries to interfere in your life?

✷ What is your role in his defeat?

✷ What does a victorious life look like?

ACKNOWLEDGMENTS

Thank you to Jenna Ghizas and Samantha Mathews for whiteboard sessions and "will you listen to this?" moments. I so appreciated your perspective as this project came to life.

Thank you to Stephanie Bennett and Michael Covington, who heard my heart for something substantial and leaned into what we created. You made me feel brave.

Thank you to my mother, Ruth Ewing, who has always fostered this sense of fight in me and never tried to pour water over the fire. You taught me to love Jesus fiercely.

Thank you to Bryan Norman, who encouraged me to think of this companion guide as something that would activate faith steps. Your view is always so valuable to me!

And as always, to Todd and my children: for every lesson, every step up, and every misstep you've had a front-row seat and I am grateful we are together, working out our faith with fear and trembling. Some of my favorite qualities about our family life are how we tell the truth, celebrate one another, create our own culture, invite others in, share without hesitation, and have fun. It takes serious kingdom warfare to protect our relationships and the space we share together. Thank you for all the moments you confessed your sin, believed the truth, and fought for one another. I love you.

APPENDIX

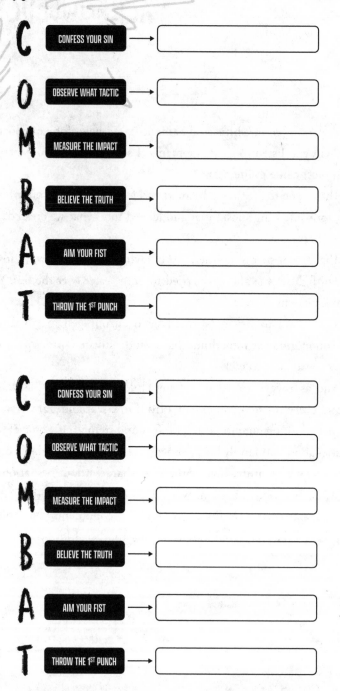

C CONFESS YOUR SIN →

O OBSERVE WHAT TACTIC →

M MEASURE THE IMPACT →

B BELIEVE THE TRUTH →

A AIM YOUR FIST →

T THROW THE 1ST PUNCH →

C CONFESS YOUR SIN →

O OBSERVE WHAT TACTIC →

M MEASURE THE IMPACT →

B BELIEVE THE TRUTH →

A AIM YOUR FIST →

T THROW THE 1ST PUNCH →

C CONFESS YOUR SIN →

O OBSERVE WHAT TACTIC →

M MEASURE THE IMPACT →

B BELIEVE THE TRUTH →

A AIM YOUR FIST →

T THROW THE 1ST PUNCH →

C CONFESS YOUR SIN →

O OBSERVE WHAT TACTIC →

M MEASURE THE IMPACT →

B BELIEVE THE TRUTH →

A AIM YOUR FIST →

T THROW THE 1ST PUNCH →

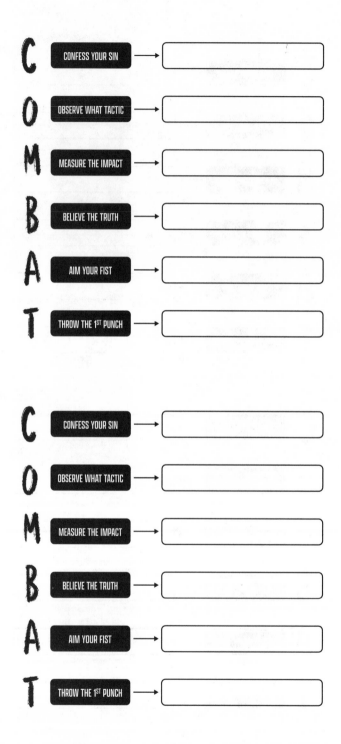

C — CONFESS YOUR SIN →

O — OBSERVE WHAT TACTIC →

M — MEASURE THE IMPACT →

B — BELIEVE THE TRUTH →

A — AIM YOUR FIST →

T — THROW THE 1ST PUNCH →

C — CONFESS YOUR SIN →

O — OBSERVE WHAT TACTIC →

M — MEASURE THE IMPACT →

B — BELIEVE THE TRUTH →

A — AIM YOUR FIST →

T — THROW THE 1ST PUNCH →

C CONFESS YOUR SIN →

O OBSERVE WHAT TACTIC →

M MEASURE THE IMPACT →

B BELIEVE THE TRUTH →

A AIM YOUR FIST →

T THROW THE 1ST PUNCH →

C CONFESS YOUR SIN →

O OBSERVE WHAT TACTIC →

M MEASURE THE IMPACT →

B BELIEVE THE TRUTH →

A AIM YOUR FIST →

T THROW THE 1ST PUNCH →

NOTES

1. Sandra Richter, *The Epic of Eden: Understanding the Old Testament* (Franklin, TN: Seedbed, 2014), n.p.

2. "Susanna's Apron: Six Tips for Prayer as a Mom," *Risen Motherhood* (blog), May 1, 2017, www.risenmotherhood.com/blog/susanna-apron-six-tips-for-prayer-as-a-mom.

3. Haley Goldberg-Shine, "How I Learned to Worry Productively," *Fast Company*, March 20, 2018, www.fastcompany.com/40543707/how-i-learned-to-worry-productively.

4. C. S. Lewis, *Mere Christianity*, rev. ed. (New York: HarperOne, 2001), 122–23.

5. Graham Cooke (@GrahamCookeBBH), "You can tell the quality of someone's inner life by the amount of opposition it takes to discourage them," Twitter, February 26, 2015, 11:10 a.m., https://twitter.com/GrahamCookeBBH/status/570979191388278784.

6. Harlan K. Ullman and James P. Wade, *Shock and Awe: Achieving Rapid Dominance*, Defense Group Inc., 1996, www.dodccrp.org/files/Ullman_Shock.pdf.

7. "The Fellowship of the Unashamed," Maranatha Bible Church, accessed July 7, 2021, www.mbcmi.org/wp-content/uploads/2015/10/The-Fellowship-of-the-Unashamed.pdf.

BIBLE CREDITS

The author has added italic and bold treatment to Scripture quotations for emphasis.